An Introduction to
GREEK SCULPTURE

FRONTISPIECE Young girl with doves:
grave relief from Paros, *c* 450–440. The
naturalistic treatment of childish arms and
feet contrasts with the idealized face and
dress. The head recalls the style of Polyclitus
of Argos, as do the proportions of the figure
(see pp. 108–114)

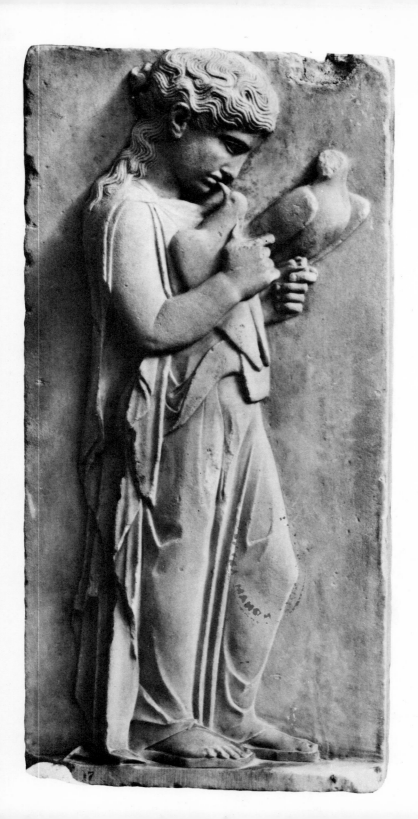

An Introduction to
GREEK
SCULPTURE

John Barron

ATHLONE
LONDON

For My Parents

First published in Great Britain, 1981, by
The Athlone Press Ltd,
90–91 Great Russell Street,
London WC1B 3PY

© John Barron

British Library Cataloguing in Publication Data
Barron, John
An Introduction to Greek Sculpture. – New
 and revised ed.
1. Sculpture, Greek
I. Title II. Greek Sculpture
733'.3 NB 90
ISBN 0 485 11196 9 Cased
ISBN 0 485 12033 X Paperback

An extended, revised and up-dated version
of *Greek Sculpture*, John Barron, 1965. Studio
Vista (London) E. T. Dutton (New York).

Printed in Hong Kong

Contents

Preface

In this book I have sought to follow the development of full-scale Greek sculpture over a period of almost exactly five hundred years, from its first beginning *c* 660 until *c* 150 BC. By the latter date the difficulties of representing flesh and cloth in stone and bronze had long since been conquered, and there was little left to achieve except in novelty of subject or virtuosity of technique. Moreover with the Roman annexation of Greece came a developing taste for the antique among both Greek and especially Roman patrons. Left with little incentive for new creation, the most skilled craftsmen were drawn into the sterile business of producing accurately measured copies of the great works of the past; and what passed for originality was commonly *pastiche*. Here, then, is the place to stop.

In the selection of works to be considered, I have had the benefit of the unfailing good judgment of my wife, who also read the whole text and improved it at many points. I am greatly indebted to the authorities of the museums on which I draw, some of whom have generously allowed me to include recently discovered material, not yet fully published. Many, too, kindly provided photographs. Detailed acknowledgements will be found at the end of the book, but I cannot omit to mention here Miss Alison Frantz in Princeton and the German Archaeological Institute in Athens, without whose help my task would have been almost impossible. How much I owe to other students of Greek sculpture will be clear on every page. Here I record a more personal debt, to those whose suggestions and patient conversation have led me to formulate and reformulate my view of Greek sculpture in the fifteen years since the first edition appeared: Professors Bernard Ashmole, John Boardman, Peter Corbett, Martin Robertson, Brian Shefton, Andrew Stewart, Homer Thompson, and my colleague at King's College London, Dr Geoffrey Waywell.

Introduction

The story of Greek sculpture is often written as if it were one of steady progress from rude incompetence to refinement of skill in the single respect of realism or naturalism. That is inadequate. Its development reflects the perennial tension in Greek thought. On the one hand there is the deeply speculative and anti-empirical cast of mind which is to be observed in so much of Greek science and philosophy – the desire of the Presocratics to identify a single primordial substance of the world, their readiness to entertain arguments for the impossibility of motion, Socrates' doctrine that the visible world is but an imperfect reflection of the world of ideas, mere shadows cast by the flickering light of a fire, Plato's belief that geometry is the best training for politics. On the other side there is the rarer but overwhelming empirical penetration of a Thucydides or an Aristotle, analysing and classifying the visible world and generalizing on the basis of observation. So with Greek art. Of course there were merely technical skills to be acquired. But essentially it is the story of the proposal of successive theoretical notions of natural beauty, and their modification through observation of the real world and through contact with the art of foreign peoples based on different ideals from the Greeks' own.

The sources of our knowledge are four-fold: the original works themselves, where they survive; copies of those which are lost, most of them produced under the Roman Empire; miniature representations on vases and coins; references in Greek and Roman literature, which provide the chronological framework and enable many otherwise anonymous works to be assigned to a known artist. The names of Pliny and Pausanias are most important here. Pliny, who died in the eruption of Vesuvius in AD 79, appended a detailed discussion of sculpture in stone and bronze to the geological section of his *Natural History*. Pausanias wrote a guide book to Greece in the second century AD in which he described the sculptural decoration of many cities and sanctuaries.

The peoples who inhabited the Greek peninsula and islands in the late Bronze Age – say 1600–1200 BC – were already skilled in fine architecture and in the life-size portrayal of human beings and animals in both sculpture and painting. Their best-known paintings, though heavily restored, are from Cnossus in Minoan Crete; and well-preserved Minoan examples glowing in the freshness of their original colours have recently been recovered from the volcanic deposit on the island of Thera (Santorini). More than one site on the mainland of Mycenaean Greece has produced comparable work. Surviving sculpture of any size is rare. But the great Lion Gate of Mycenae shows what could be done, and recent finds of terracotta figures on the island of Ceos have filled out the picture. The Minoan–Mycenaean

civilization perished by violence in the twelfth century BC; and although its artistic achievements were remembered in heroic poetry such as the *Iliad* and the *Odyssey*, the succeeding four hundred years of darkness have left us little in the way of sculpture but a few rude animals in terracotta. The Greeks of that period were not much drawn to representational art: they preferred to decorate their pottery with increasingly refined geometric motifs of circles and triangles and key-patterns. But during the eighth century vase-painting, especially in

Athens, showed a new interest in narrative representation – in which, however, the human or animal participants are introduced as a further variety of repeating pattern, and the living body is analysed in terms of geometrical figures (RIGHT) This conceptual approach to nature – analogous to the Cubists' view in our own century – is evident also in the triangular, tubular and other elements which go to make up the small bronze figures and groups which now began to appear. One such group may serve to

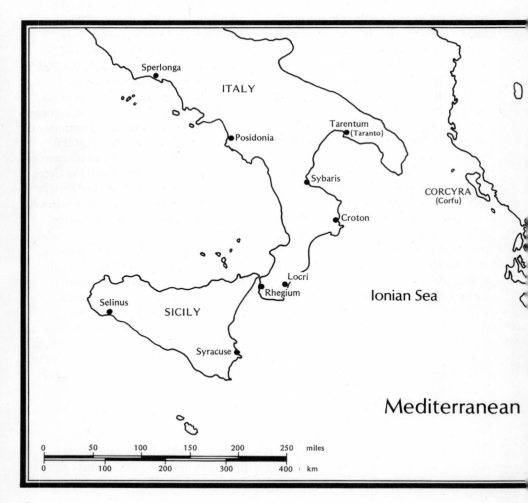

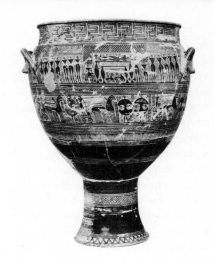

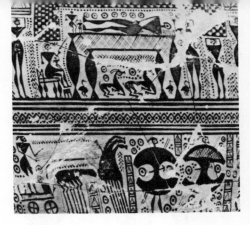

LEFT Late Geometric *krater*, Athenian, *c* 750
ABOVE Detail of same *krater*

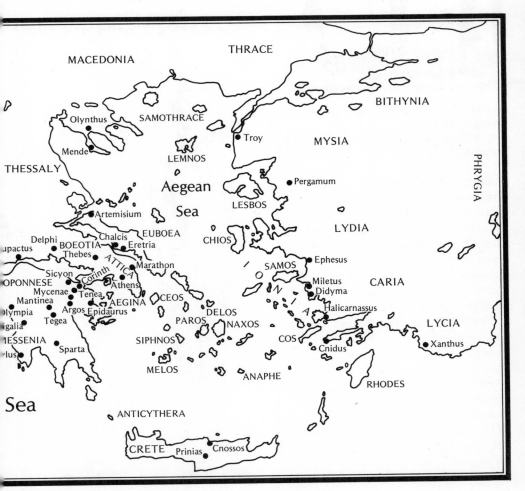

THRACE

MACEDONIA

BITHYNIA

Olynthus

SAMOTHRACE

Troy

MYSIA

Mende

LEMNOS

THESSALY

Aegean

Pergamum

Sea

LESBOS

Artemisium

PHRYGIA

LYDIA

Delphi

Chalcis

EUBOEA

CHIOS

upactus

BOEOTIA

Eretria

Thebes

Marathon

SAMOS

Ephesus

ATTICA

Sicyon

Corinth

Miletus

Athens

CARIA

OPONNESE

Tenea

Didyma

Mycenae

AEGINA

CEOS

Halicarnassus

Mantinea

Argos

Epidaurus

DELOS

lympia

PAROS

NAXOS

LYCIA

igalia

Tegea

ESSENIA

SIPHNOS

COS

Cnidus

Xanthus

lus

Sparta

MELOS

ANAPHE

RHODES

Sea

ANTICYTHERA

CRETE

Prinias

Cnossos

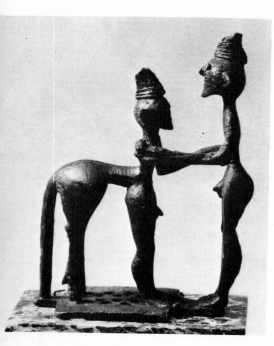

ABOVE), with conventionally tubular body, angular limbs and dappling of concentric circles, conveyed a touch of realism in the oblique angle of the sucking fawn. The material of the former work and the subject of the latter remind us that the eighth century saw the resumption of Greek overseas contacts; and the steady import of near-eastern goods – ivories, bronzes, embroideries – could not fail to have its effect on native art. The effect might be more or less extreme.

A bronze statuette dedicated to Apollo in Boeotia at the beginning of the seventh century still illustrates the geometric tendency (OPPOSITE, BELOW LEFT): head

ABOVE Man and Centaur, bronze statuette, from Olympia, *c* 750
RIGHT Girl wearing *polos*, ivory statuette, from Athens, *c* 750

illustrate the style (ABOVE). Evidently mythological, it represents a male figure attacking a centaur (a trace of his sword remains on the creature). From these beginnings *c* 750 BC, which owed little if anything to the earlier achievements of the Bronze Age, stems the whole developing tradition of western representational art.

The intellectual element was unusually dominant in Geometric art, and its susceptibility to modification through contact both with the visible world and with imported foreign artefacts correspondingly great. Already *c* 750 an Athenian ivory carver relaxed the rules of his art to give the first credible impression of the nude female form (RIGHT); and the creator of a bronze group of reindeer and young (OPPOSITE,

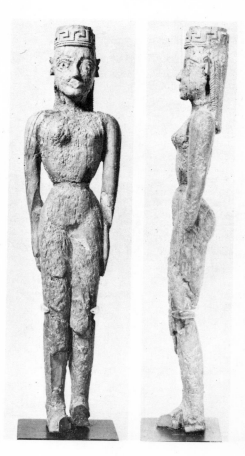

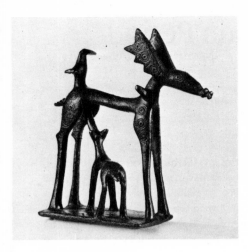

ABOVE Reindeer and fawn, bronze statuette, *c* 750

and torso are basically triangular, the eyes are circles, vertical lines bisect the figure symmetrically. The only dress is a broad belt, characteristic of male figurines of the period. By contrast, an ivory figurine of a god with a diminutive lion at his side is an extreme instance of the oriental impact (BELOW, RIGHT): the narrow forehead, enlarged eyes and nose, fleshy mouth and deep chin, together with the emphasis on curvilinear surface calligraphy, are characteristic of native Syrian and Assyrian work. Their adoption in Greece marks the acceptance of a new canon of taste, which was still to prevail when large-scale sculpture began.

LEFT Bronze statuette, from Thebes, 700–650
BELOW God with lion, ivory statuette, from Delphi, 700–650

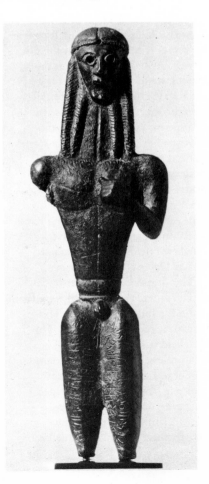

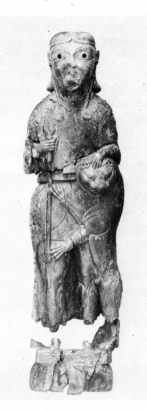

1 The Early Archaic Period
c 660 - 580

Full-size sculpture in stone began c 660. The inspiration was found in Egypt, which the Greeks penetrated at this time in considerable numbers, first as mercenaries helping to bring about the accession of the XXVIth Dynasty in 664, then as merchants expressing the commercial interest in Egypt shown by some of the foremost Greek cities under their energetic popular dictators or 'tyrants'. Between the collapse of Mycenaean civilization and the reopening of Egypt, a period of some five and a half centuries, the Greeks had created no fine architecture, no monumental sculpture, no large-scale painting. Now within a single generation all three major arts sprang confidently to life under the impact of the extraordinary richness and monumental scale of the sights of Egypt. From this initiative the next two generations, the Early Archaic period from c 660 to c 580, saw the beginning of the use of sculpture in relief or in the round for nearly all the purposes for which the Greeks ever used it: the decoration of temples and tombs, images of deities to form the focus of a cult, offerings to the gods to recall a memorable event or to commemorate the devotion of the donor. The great exception is portraiture, which did not begin until the fifth century, in the final decisive break with formalism.

The earliest stone sculpture, called 'daedalic' after the legendary first sculptor among the Greeks, Daedalus, is found in the east Greek region from which the mercenaries sailed to Egypt – Naxian work on Delos, several marbles on Samos, a female figure at Clarus in Asia Minor. But the style quickly spread to the Peloponnese and Crete. The daedalic artists concentrated on free-standing male and female figures, *kouroi* and *korai* ('boys' and 'girls'). The pose of each is based on Egyptian models. The male statues are nude, standing frontally with one leg set forward and arms at the sides with fists clenched. The *korai*, on the other hand, stand with their feet together, and are always clothed. The difference between the sexes is striking. It is also very Egyptian, save that Egyptian males wear a kilt. *Kouroi* and *korai* seem to have served two main purposes: to represent worshippers in permanent attendance on a god in his sanctuary, or to mark a grave.

Of the earliest statues, only *korai* have survived complete. The very first was dedicated by Nicandre the Naxian to Artemis at Delos c 660 (OPPOSITE, LEFT). The drapery is without folds, even where the feet hold it up from the ground: a long belted tunic, and a short cape across the shoulders. The arms are held stiffly to the sides. The face, now featureless, is the inverted triangle of the geometric artists. The hair is a formal wig, four vertically divided locks hanging down on to either shoulder. A similar but rather later statuette formerly in Auxerre has been

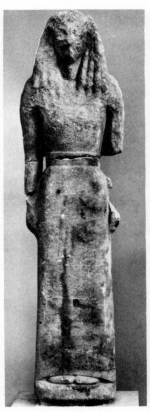

Kore dedicated by Nicandre
at Delos, *c* 660

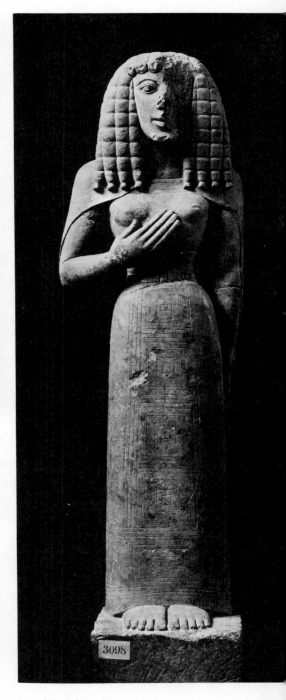

thought to be of Cretan workmanship;
its material, limestone, is the only
substantial evidence (RIGHT).
Dress and stance are the same, except for
the gesture of the right hand held to the
breast. In both these statues there is a
serious attempt to suggest the bodily
forms above the waist. But below there
is none: not even a groove to mark the
parting of the legs. Still there are no folds
to the drapery, though some dawning
recognition of the obstruction of the feet
can be seen in the upward curve of the
hem of the skirt, followed in the
Auxerre figure by the pattern of the
geometric embroidery. The latter is
shown by incision, originally filled with

Kore formerly in Auxerre,
limestone statuette, 650–625

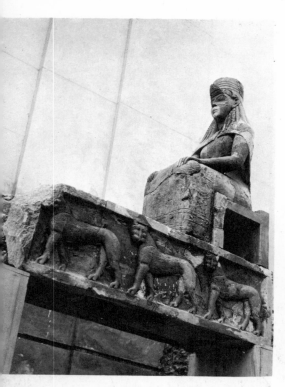

paint: polychromy was to be the rule on both free-standing and architectural sculpture throughout the archaic and classical periods. In the Auxerre figure we see the features of the still triangular face, large and formal with thick-lipped mouth, long nose set high, prominent eyebrows. In these features, as in the wig-like hair, the influence is not of Egypt but of Syria: if the temptation to large scale was evidently Egyptian, the detailed facial style is that developed in the first half of the seventh century for miniature work, now enlarged to suit the new purpose. This may perhaps indicate that the artists owed less to autopsy than to descriptions given by their patrons, so finding novel application for a familiar style.

Apart from free-standing figures such as these, there is also daedalic architectural sculpture. The most important is from the temple at Prinias in Crete. The lintel of the entrance supported a seated *kore*, probably a goddess, at either end, roughly half life-size and dressed like the standing *korai* with the addition of a cylindrical hat (*polos*) and thick boots

ABOVE Seated Goddess from temple at Prinias, Crete, limestone, 650–625
BELOW Frieze of horsemen, from Prinias, limestone, 650–625

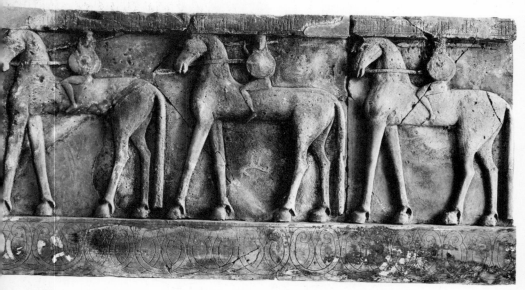

(LEFT, ABOVE). Again, the upper part of the body is modelled, the lower cut as a squared block as monumental as the throne on which she sits. This perfunctory formalism is in sharp contrast with the careful carving of animals embroidered on the skirt, and the friezes of panthers and stags which decorate the sides of the lintel itself. The pose of the seated goddess too is Egyptian.

A frieze of horsemen of this period may come from the same temple (LEFT, BELOW). The long legs and comparatively thin barrel of the horses recall geometric work; but the forms are at least distantly related to nature.

Architectural sculpture in relief was already known to the Greek mainland also. A relief from Mycenae with the bust of a *kore* may have decorated an altar (BELOW). The features are nearly the same as in the figure from Auxerre. But the variations are pleasing: the hair no longer separated into locks, and the double row of curls crossing the forehead; the cape drawn over the head and across one side

Relief of a *kore* from Mycenae, limestone, *c* 625

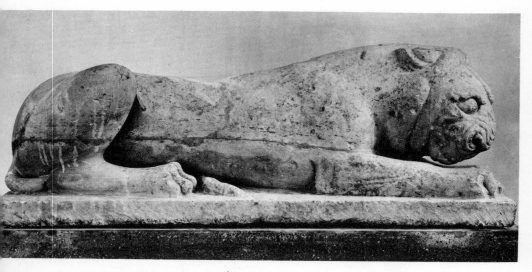

Lion from tomb of Menecrates, Corfu, *c* 625

of the body to break the monotony of total symmetry. All the works examined so far, apart from Nicandre's earlier *kore*, belong to the quarter-century *c* 650–625.

The modelling of animals had clearly reached a high artistic standard by *c* 625. A limestone lion found near the tomb of Menecrates in Corcyra (Corfu) is a sufficiently awesome guardian for the dead (ABOVE). The formalized treatment of the head makes it clear that the only lions seen by the artist were derived from oriental art, not creatures of nature. But the shaping of the haunches, shoulders, paws, and forehead, shows that the sculptor was a student of live animal forms in general. He even represents sinews beneath the skin of the forelegs.

Another work executed in limestone at Corcyra is the earliest pedimental composition to have survived (OPPOSITE). According to the poet Pindar in the mid-fifth century, the pediment was a Corinthian invention; and it is significant that this earliest example, dated *c* 600–580, is of Corinthian style and carved at a time when Corcyra was under direct Corinthian rule. It filled the west gable of the temple of Artemis, and the east bore a similar group. In the centre, the winged Gorgon Medusa flies across the scene. The half-kneeling pose is the regular archaic convention for any rapid motion, whether running or flying (pp. 27, 34). She wears a short tunic,

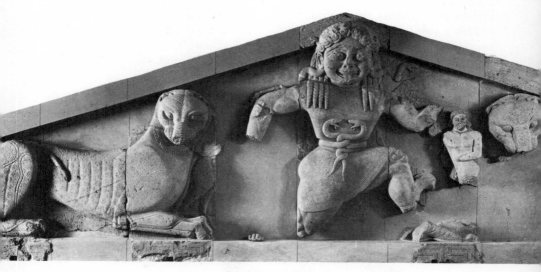

Medusa and panthers, limestone pediment, Corfu, 600–580

belted with a couple of bearded vipers. Her horrific grin had the power to turn to stone all who set eyes on her. On either side are miniature figures of her two sons, Chrysaor and the winged horse Pegasus (only his haunches remain), who sprang from her head when it was cut off by the hero Perseus (p. 27). On either side again are two large protectors unknown to nature: their manes suggest lions, but the spots (compass-drawn concentric circles) are those of panthers. In the angles were miniature groups representing a different subject, the battle of the gods against the presumptuous race of giants (or Titans) who threatened the rule of the gods. On the right, Zeus uses his terrible thunderbolt against a giant, while

another lies dead in the corner. In the left corner is yet another dead giant, then a seated figure, probably female, menaced by a spear. The use of corpses for the extremities is a device which commonly recurs in the design of pediments. The variation of scale and subject prevent the pediment from achieving much artistic unity. It may be noticed that the sculpture is in relief, like all early pediments. The use of free-standing statuary for this purpose did not begin until c 525 (see p. 41). Like all Greek stone sculpture, these reliefs were painted, and the design will have stood out boldly when viewed from the ground.

From this same period, we have what was probably the head of a cult statue of

Hera at Olympia (OPPOSITE). Larger than life, the goddess was seated in her temple with her husband Zeus standing at her side. The 'archaic smile' characteristic of early Greek sculpture is clearly visible. Less exaggerated than often, it gives the open face a genuinely friendly look, reflected also in the keen eyes with their compass-drawn irises. On the head was a crown of vegetation, emphasizing the goddess's role in agricultural fertility. Some idea of what the whole figure may have looked like may be gained from

the earliest of a long series of seated statues of life-size and more, dedicated to Apollo at Didyma near Miletus, on the west coast of Asia Minor (BELOW). The pose is similar to that of the goddess from Prinias, basically Egyptian. The anatomical forms of the lower part of the body begin to make a hesitant appearance. There is still no progress in the problem of making the figure look as if it could rise up from the throne.

So far we have seen no standing male statues. The most widespread type in the

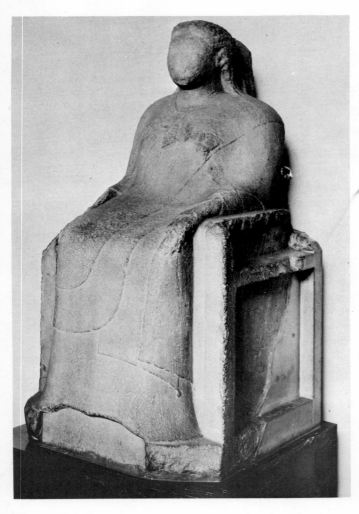

LEFT Seated statue from Didyma, 600–575

RIGHT Head of Hera, from Olympia, limestone, c 600

18

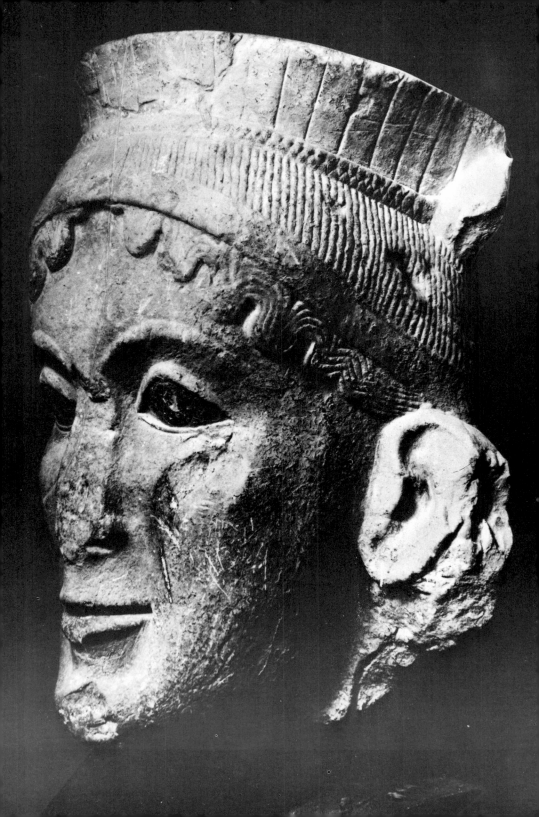

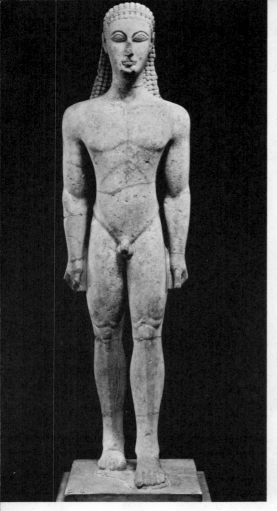
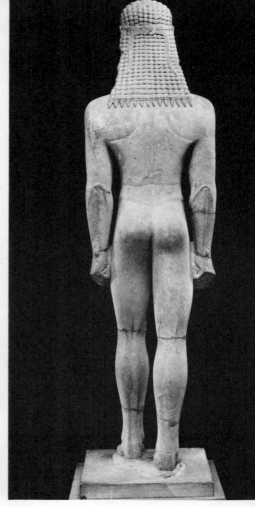

archaic period is that known as the *kouros*,
a nude youth standing with arms at his
sides, with one foot advanced (almost
always the left) and his weight evenly on
both feet, gazing straight ahead. The
stance is of course derived from the kilted
male figures of the Egyptians, with the
important difference that in the latter the
weight is taken on the rear leg alone. One
of the earliest complete *kouroi* comes
from Attica, and is one of the first
surviving works by an Athenian sculptor,
made *c* 610–590 (ABOVE). This statue is
exceptional in that the artist evidently
worked to the Egyptian canon of

proportions, at any rate along the vertical
axis of the figure: no longer was the
Egyptian inspiration merely a matter of
hearsay, but of detailed study. As to style,
everything is formalized in a system of
knobs, ridges and grooves, and there is
particular interest in correspondence of
line between one anatomical groove and
another. Though still a stylized wig in
appearance, the hair hangs better than on
the Auxerre *kore* (p. 13). It is held by a
ribbon tied in a reef knot. There is
a collar about the neck. The features are
large and bold, with eyes bulging in the
oriental manner.

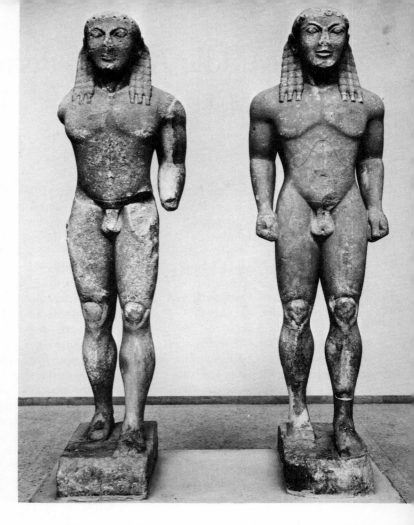

LEFT *Kouros*
from Attica,
610–590

RIGHT Cleobis
and Biton,
Argive *kouroi*,
c 600

From Delphi comes a pair of *kouroi* of similar date (ABOVE). They are Cleobis and Biton, two brothers proverbial for their good fortune. Their mother desired to drive to the temple of Hera at Argos for the festival. But as there was no time to lose and the oxen were away working in the fields, her two sons harnessed themselves to the waggon and drew it to the temple in good time. The bystanders congratulated the mother on her fine children, and she prayed to Hera that they might receive the greatest blessing possible for mankind. After the festival had ended, everyone passed the night sleeping in the temple. But Cleobis and Biton never again awoke: they died, and so were remembered in the hour of their glory, and for a Greek this was good fortune indeed. So, says Herodotus, the people of Argos had statues made of them, which they sent to Delphi as a signal mark of respect. There is of course no attempt at portraiture: each figure is a replica of the other. But these two *kouroi*, signed by the Argive sculptor Polymedes, certainly convey in their Peloponnesian style a better impression of life and vitality than does the Athenian *kouros*.

2 The Middle Archaic Period
c 580-540

We pass to the Middle Archaic period, c 580–540. This was, especially in the East Greek region of the coasts of Asia Minor, a time of great commercial activity often under the leadership of dictators or 'tyrants', in which large profits were made from trade overseas. The wealth which flowed into Greece paid for an ever-increasing number of personal and public dedications, of statues and of buildings. The dictators themselves were active patrons of the arts. The period ends with the advance of the Persians to the west coast of Asia Minor, and the consequent eclipse of the East Greek cities, which in turn led many of their artists to move westwards and seek employment on the mainland, especially in the expanding city of Athens.

Sculptors of the Middle Archaic period show a great advance in attention to the plastic qualities of the subject; they have lost their predecessors' apparent desire to show what a man would look like if he were made of stone, and the formalism of anatomy has been modified by such continual observation of reality as the Greek fashion for nude athletics freely afforded.

The technical inventiveness which was the chief tool of Greek enterprise of the time was applied to art, and one of its triumphs was the development c 570 of a method of hollow-casting large bronze statues, by two sculptors of the island of Samos. Previously, bronze figures had been made of plates nailed to a wooden frame, and the rotting of the wood prevented long survival of complete examples of the art. Now a bronze statue could stand in its own strength, and the tensile quality of the material is such as to encourage an ambition to portray complex movement. This liberation of Greek sculpture from the demands of brittle materials was the single most important source of its developing inventiveness. It was a technique the Egyptians never adopted: to a great extent the monotony of Egyptian art was dictated by the limitations of the materials used. For the moment, however, the majority of Greek artists continued to work in stone; it was not until the fifth century that bronze became the regular material for non-architectural work of any pretensions to grandeur.

When the Middle Archaic period opens, one of the most important schools was centred on two islands, Naxos and Samos. The stylistic unity of the group is marked by the statues' sharing of an unusual technical device, the representation of folds of drapery by parallel grooves set close together and finished by abrasion with Naxian emery. One of the earliest works of this school is the sphinx at Delphi, dedicated by the Naxians c 575–560 (RIGHT). She sits on a tall Ionic column; the Ionic order seems to have been originally developed for such use, and only subsequently to have become an alternative to the plain

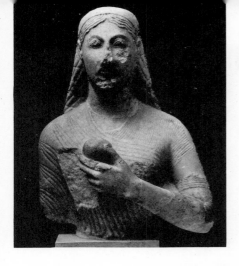

Doric for use in the construction of buildings. The style of the head may be compared with that of the *kore* no. 677 in the Acropolis Museum, at Athens (LEFT). We see the same plain, open features, the spinsterish parting of the hair, the eyes with straight lower and arched upper lids. The etched effect of the drapery is very plain to see, especially on the right arm with its folds gathered in fours at the seam. The statue is of Naxian marble. Two other works of the same material, headless, must have been

ABOVE *Kore* (No.677) from Acropolis, Athens, 570–550
RIGHT Naxian sphinx at Delphi, 575–560

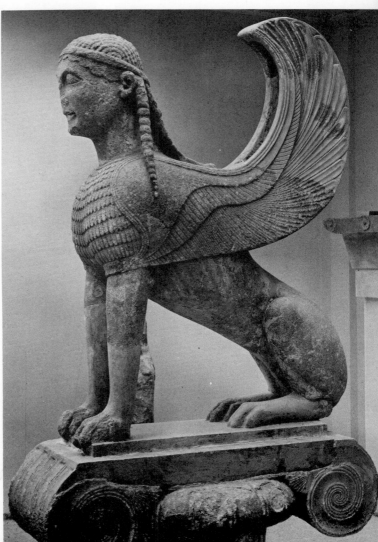

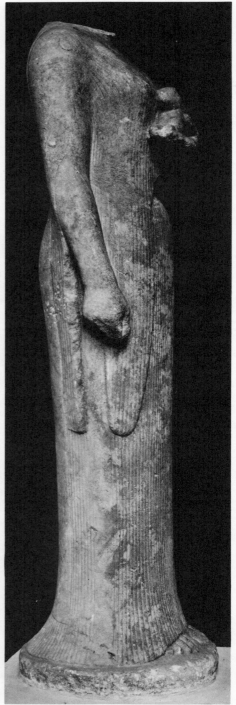

very similar. One is in the Louvre
(OPPOSITE, LEFT), the other in Berlin
(OPPOSITE, RIGHT). Both come from the
sanctuary of Hera at Samos, and carry
a vertical inscription on the hem of the
cloak at the front, to say that Cheramyes
dedicated them to the goddess. There is
still something of the tree-trunk about
these figures, recalling the tradition that
a piece of wood, not carved to human
shape, once served as the object of the
cult. The artist has made little attempt to
show the proper relation of one part of
the body to another. The feet are
enormous; but the unnaturally high waist
contributes to the majesty of the figure.
A few years later, another sculptor of the
school created one of the earliest free-
standing group compositions, again at
the temple of Samian Hera, but this time
of local marble (ABOVE). He signed his
name, Geneleos, and also labelled the
individual figures, evidently members of
a family. At one end, Phileia is seated,
wearing the Ionic *chiton* or tunic, and
swathed in a voluminous *himation* (cloak).
Geneleos has still not quite solved the
problem of distinguishing figure from
chair. At the other end reclines a male

figure, . . . arches, the dedicator of the
group. Between were four standing
statues, leaded into the base. Philippe
survives in Samos, her younger sister
Ornithe ('little bird') in Berlin. A new
interest has been added to the figure by
setting one foot in front of the other, and
by making the right hand grasp the skirt
and draw it to the side, so raising it from
the ground. As a result, the etched folds
take on a new pattern, and the tautness
of the cloth against the opposite leg
begins to disclose its anatomical form.
Both devices became a permanent
feature of the *kore* all over Greece.
The pose is more relaxed than that of
Cheramyes' figures (OPPOSITE). The
dress is the Ionic *chiton*, a piece of cloth
wrapped horizontally about the body,
and sewn at one side and across the top
with holes left for head and arms; belted,
with a generous fold falling over the belt.

At the other end of the Greek world,
the colonial settlements in Sicily and
southern Italy were enjoying a period of
great prosperity and displaying their
wealth in the construction of grandiose
and colossal Doric temples. Several
temples at Selinus in south-western Sicily

25

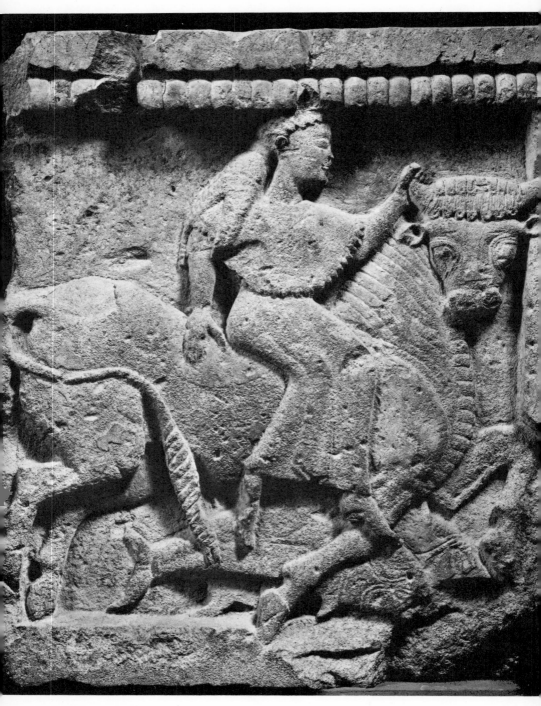

Europa and the Bull, metope from Selinus, *c* 560

bore sculptured metopes (cf. pp. 62, 63), square reliefs which alternated with vertical bands and grooves known as triglyphs, high on the building above the architrave (see illus. on pp. 94–5). Europa riding on the bull comes from Temple Y, *c* 560 (LEFT). She was loved by Zeus who became, or sent, a friendly bull which carried her off to Crete, where among other children she bore to Zeus King Minos of Cnossus. Here Europa affectionately grasps the bull's horn as they cross the sea, which is represented by dolphins. The placing of the bull's legs admirably conveys his rapid motion. Europa's figure is an alternation of profile and frontal sections, uncoordinated in the manner of the period. This way of showing each part in its most characteristic aspect is a mark of the conceptual artist, no mere illusionist. However, in Europa's right foot there is an illusive touch, an interesting attempt to show a three-quarter view. Temple C was built perhaps twenty years later. One of its metopes shows Perseus in winged boots and short tunic cutting off the head of the Gorgon Medusa (RIGHT: cf. p. 17), while her son Pegasus, the winged horse, leaps up at her side and Athena stands next to Perseus to lend support. The treatment of the drapery folds, though flat, is more naturalistic than we have seen. Medusa repeats the conventional pose for rapid motion, and all three figures show again the alternation between profile and frontal view. It is

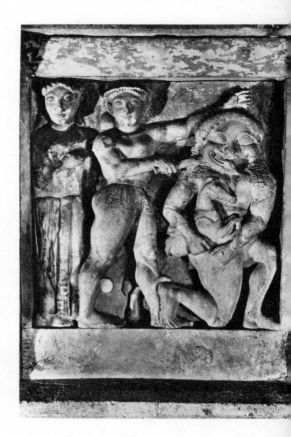

Perseus beheading Medusa, metope from Selinus, *c* 540

acceptable as a convention for a figure in motion, but disastrous in one at rest, as Athena is here.

To compare with the works of these eastern and western artists, we may look at contemporary achievements of the mainland: first, a *kore* from Keratea in Attica (FAR RIGHT). Broad-shouldered and stocky, she wears *chiton* and *himation*, and the folds are treated as truly three-dimensional. The sandalled feet are carefully modelled. The pointed nose and wide eyes with arched brows give the figure an exceptionally alive and alert look. A male figure of very similar style comes from Tenea, near Corinth (RIGHT). We see the same broad, sloping shoulders, the same hair-style, the same look of keen interest in the face. Though the feeling for the body as a

formal design is still strong, the individual parts of it are no longer represented by engraved lines, as on the Early Archaic *kouros* from Attica (p. 20); each shape is genuinely modelled as a three-dimensional object, and there is a considerable advance in the task of showing the relationship of one part to another. Both the Keratea *kore* and this *kouros* from Tenea belong to the second quarter of the sixth century. Slightly later, *c* 550, we see the style repeated in a fragmentary tombstone from Attica (BELOW). The dead man was evidently an athlete, for his head is shown outlined against a discus. The features are very like those of the Corinthian *kouros* from Tenea, except that the nostril and the line of the jaw are more firmly modelled. Like much of contemporary Athenian

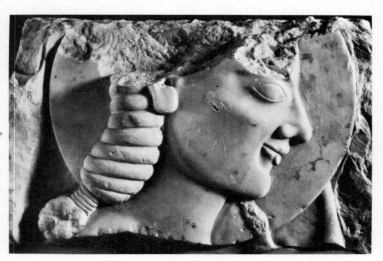

LEFT Fragmentary gravestone of a discus-thrower, Attic, 560–550

RIGHT *Kouros* from Tenea, 570–550
FAR RIGHT *Kore* from Keratea, Attica, *c* 570

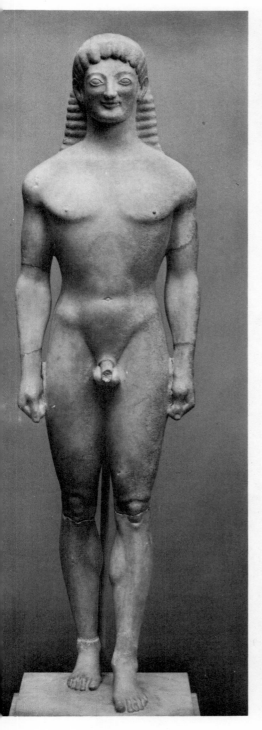
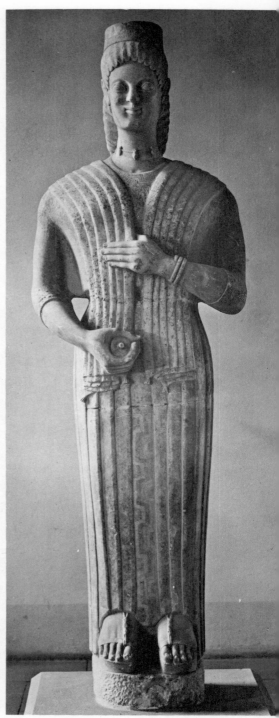

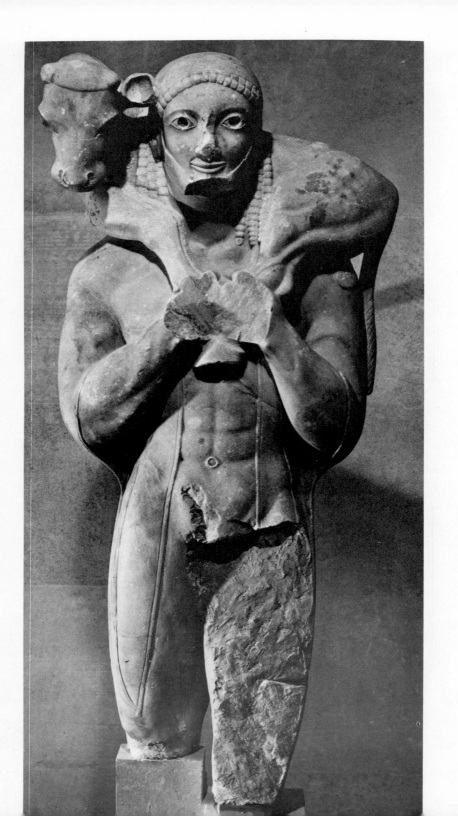

vase-painting, these three works of sculpture emphasize the close connexion between Athenian and Corinthian artists, probably to be explained by the migration of Corinthian craftsmen to the greater security of Athens when their own city fell into discord at the end of the dictatorship in 582.

Other works of *c* 575–550 from Athens are relatively free of such external influence. The statue of a man carrying on his shoulders a calf intended for sacrifice, dedicated on the Acropolis by one (Rh)ombus, shows equal feeling for human and animal forms (LEFT). The man is well-built, with broad shoulders and powerful arms. He is naked but for his *himation*, open at the front. The hair retains the formal arrangement of the Early Archaic period, but shows a movement towards naturalism in the way in which it is displaced by the calf. The latter is extremely uncomfortable; but the cross-shaped composition of its legs and the man's arms is artistically most effective.

Of equally native style in the second quarter of the century, we have several architectural groups from the Acropolis. Among them is a limestone pediment in a style so close to that of the calf-bearer that it is most probably a work of the same artist (BELOW). In the left angle (not illustrated) Heracles wrestles with the sea-serpent Triton. Watching from the opposite side is a monster of a type popular in archaic Greece. His upper part is human, and triple; below the waist he is three twining snakes, with a pair of beating wings (preserved only at the sides). Each figure of the human upper part bears an object in his left hand – from left to right, a stream of water, flames and a bird – these three objects perhaps signifying the monster's ability to change into any of them, should he too attract Heracles' hostile attention. Who or what occupied the centre of the composition, we cannot say. The interest of these sculptures is enhanced by the excellent preservation of their paint, giving a clear impression of what a pediment really looked like.

One of the most attractive Athenian works of the period is a man on horse-back (OVERLEAF), originally one of

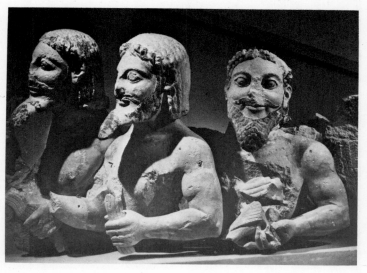

a pair of such figures. The head, formerly
in the Rampin collection, is in Paris, the
body in Athens. The artist was clearly
excited by the treatment of hair, in the
horse's mane as well as on the rider's
head. The pattern of the wreathed head
and beard is most decorative, and

BELOW 'Rampin' horseman, Attic, 560–550

RIGHT Grave monument with sphinx,
Attic, 540–530

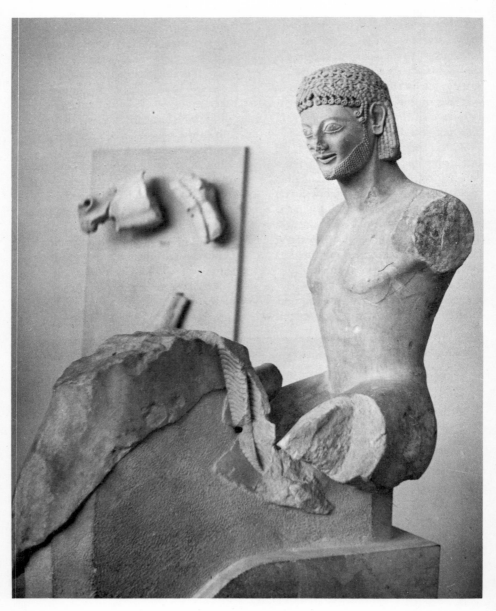

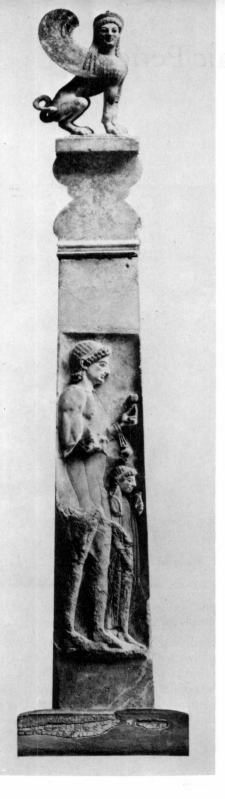

particularly effective where the hair meets the forehead. The modelling of the face is equally successful: the cheeks are almost fully natural, and the stylized eye shows a close acquaintance with nature.

The last Athenian work of this period to be considered is the most magnificent of archaic tombstones (LEFT). It stands over thirteen feet high. The inscribed base gave the name of the dead youth, and the fact that his father erected the monument. Above, and restored in outline, the dead youth is seen with his little sister: higher again, a double volute crowned by a splendid sphinx who rests on column-like front legs but nevertheless seems poised ready to fly off suddenly. The double volute is unsculptured, shown in outline only Originally both it and the whole monument were painted in vivid colours. This work is less of a virtuoso piece than was the Rampin horseman; but both the youth and the sphinx show a great advance in the understanding of bodily forms, and lead us into the Late Archaic period, when the outstanding problems were at last resolved.

3 The Late Archaic Period
c 540-480

As a result of the Persian conquest of Asia
Minor, c 540, the East Greek region
declined in importance. During the years
which followed, Athens moved forward
to take up that position of pre-eminence
which she was to hold throughout the
fifth century. The foundations were laid
under the government of the benevolent
dictator Pisistratus and his less popular
sons Hippias and Hipparchus, and
consolidated by the democratic
government which first began to rule
during the last decade of the sixth
century. Pisistratus, like other dictators
among the Greeks, set out to improve the
appearance of his city by a vigorous
programme of public works, and also
gave enormous encouragement to
practitioners of all the arts. In this period,
therefore, Athens became ever more
clearly the centre of artistic development,
and even more foreign craftsmen came
to join and influence the local artists
already at work. Prominent among them
were East Greeks, who preferred the
government of Pisistratus to that of the
Persians.

The extent of their influence may easily
be seen. An inscribed base from Delos
was signed by the East Greek sculptors
Micciades and Archermus of Chios, and
seems to have carried a figure of Victory
(Nike). The winged goddess is seen in the
kneeling–running pose which we have
met before, one hand on her hip, the
other raised in salute (ABOVE). Head and
chest are frontal, the legs in profile. The

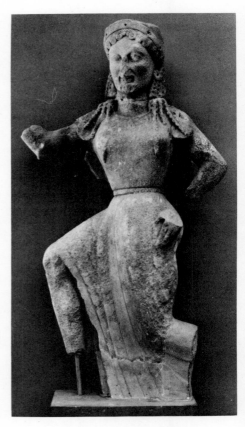

Nike perhaps by Archermus of Chios,
from Delos, c 550

modelling of the face, and even the detail
of the treatment of the hair of this East
Greek work, is closely recalled by the
best of the *korai* at Athens, no. 679, made
perhaps a decade later (OPPOSITE). The
similarity is particularly noticeable in the
eyes and mouth. The outer dress of this
kore is the *peplos*, an oblong piece of

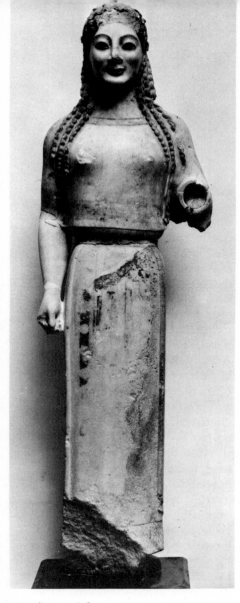
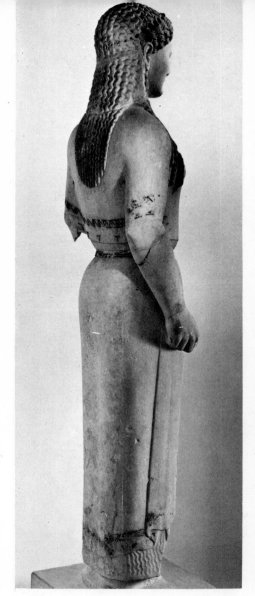

Kore (No.679) from Acropolis, Athens, *c* 540

woollen cloth wrapped about the body horizontally and pinned at the shoulder, with a wide margin left at the top to be turned out over the chest, reaching to the waist. It is worn over a petticoat of finer material, to be seen hanging in narrowly waved folds below the bottom hem. In Greek art the usual effect of wool is rather to conceal than to reveal the contours of the body (cf. pp. 29, 68, 69, 72, etc.). Here, without clinging in the manner of the linen *chiton* (cf. pp. 36, 47), the *peplos* gently moulds the body and follows its lines everywhere except at the front of the skirt, which is made taut by the bunching of folds at the sides.

The stiff symmetry of the kore is imperceptibly relaxed. The right arm hangs almost free of the body while the left, made in a separate piece, was extended forward carrying some small object as an offering. The effect, well observed, is to lift the left shoulder and

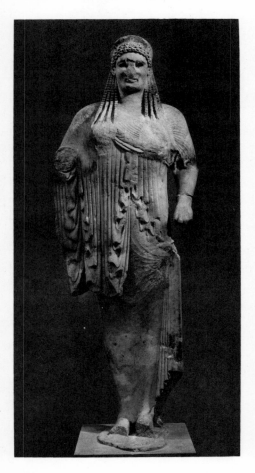

to attract a slight turn of the head. This statue has links not only with the Victory from Delos but also, and even more closely, with a newly found *kore* made for one Phrasiclea by the immigrant Aristion of Paros. But it also has affinities with the Rampin horseman (cf. p. 31), and it is hard to say whether it is itself the work of an Athenian or of an immigrant.

Standing female figures were a most popular form of dedication on the Athenian Acropolis. Two more, dressed in the Ionic *chiton* and *himation*, which began to replace the *peplos* from mid-century onwards, will serve to illustrate the type. One, Acropolis no. 681, formerly mounted on a probably alien base signed by the sculptor Antenor, seems to reflect something of the heaviness of the East Greek style (LEFT). It appears to be by the hand of an artist who also worked on the east pediment of Apollo's temple at Delphi between 513 and 510 (cf. p. 42), and should be of similar date. Gazing steadily ahead, the *kore* tugs violently at the side of her skirt. Broad-shouldered as she is, the *himation* largely supported on her extended right arm makes her look even more top-heavy. The other representative of the *korai*, no. 674, is a quiet, self-possessed figure of native style, made during the last decade of the century (RIGHT). Like no. 681, she wears the *himation* over her right shoulder. But, naturalistic though the folds are, great care has been taken to avoid a similarly

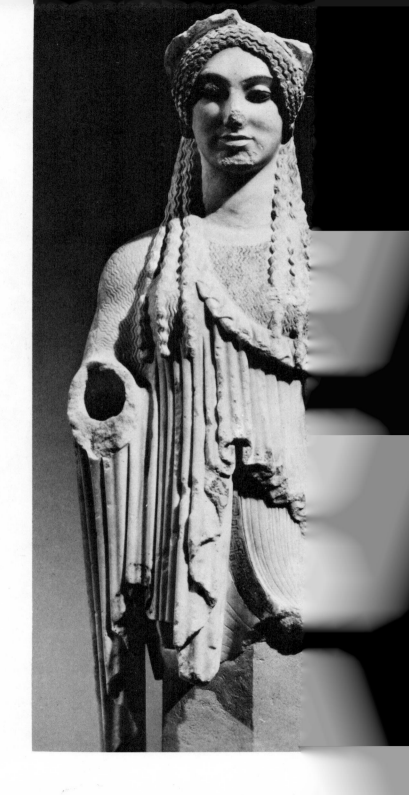

OPPOSITE
Kore (No.681)
from Acropolis,
Athens, 530–525

RIGHT
Kore (No.674)
from Acropolis,
Athens, *c* 510

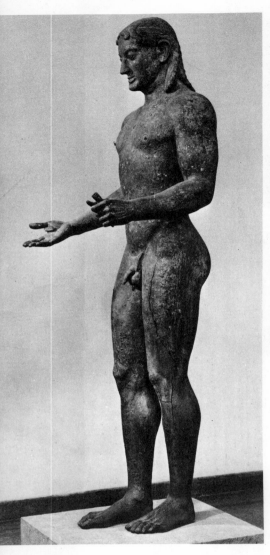

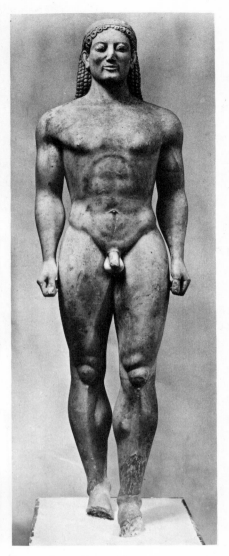

Kouros 'Croesus' from Anavysos,
Attica, 540–525

Bronze *kouros* from Piraeus
Attic, *c* 530

overpowering heaviness. The crinkled
surface of the *chiton* on the shoulders
forms an effective contrast. The hair is
thin and thought of as a true part of the
head, not as a separate wig. The modelling
of the cheeks is excellent, and the eyes are
beginning to recede correctly into their
sockets. This figure, like no. 679, carries

considerable traces of its original paint
(cf. illus. p. 35).

Kouroi continued to be produced.
Among them, dated *c* 540–520, is our
earliest life-size statue hollow-cast in
bronze by the method developed in
Samos (ABOVE, LEFT). Within the
conventions of the type, this figure

expresses its individuality not only in the advancing of the right foot rather than the almost universal left, but in the downward gaze, concentrating on the libation bowl and bow which the hands once held, and which here identify Apollo himself. In the position of the arms we discern the first stirring of movement which the new technique allowed, and which stonecarvers sought to follow as best they could, often by attaching separately carved limbs (cf. pp. 35–7). No such effort was made by the contemporary sculptor of the youth Croesus (LEFT), named after the proverbially rich king of Lydia (560–546) and presumably born during his reign. In these two figures for the first time one really begins to see a credible human form. Compare, for example, the knees of Croesus, the inner muscle correctly shown larger than the outer, with the knees of the early *kouros* in New York (illus. p. 20), or even with those of the *kouros* from Tenea (illus. p. 29). But unnatural details remain, for instance the third horizontal division of the stomach muscle, absent in nature. The extent of the progress made in the Late Archaic period can best be illustrated by comparing Croesus with the so-called Critian boy from the Acropolis, made *c* 490–480 and foreshadowing the style of Critius and Nesiotes (RIGHT: cf. illus. p. 58). The boy is younger, less muscle-bound. But the chief difference is in the placing of the weight on one foot,

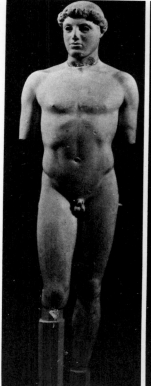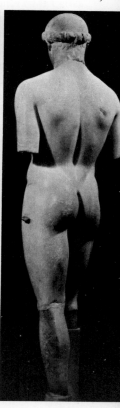

'Critian boy',
Attic, 490–480

throwing out the hip, and in the turning of the slightly inclined head. The resulting S-curve of the body gives it movement. In the expression of the small-featured face we seem to see a figure quietly musing: gone is the grin which masked the vacant mind of the earlier *kouros*.

The dictator Pisistratus died in 527. But the prosperity he had brought Athens continued under the rule of his sons, who commissioned new public buildings and so gave scope to architectural sculptors. On one of these buildings, a temple on the Acropolis constructed *c* 525–520, we find the earliest use of free-standing rather than relief sculpture for pediments. The subject of the surviving composition is the battle between the gods and the giants who had sought to usurp their authority. It is a scene of violently striding figures, framed by fallen giants in the corners (BELOW). In one group as restored, Athena is seen standing behind a fallen giant, whose legs are in profile and his chest frontal (RIGHT). We can see an early attempt to mark out the transition anatomically, in the wrenching of the arched line which forms the lower boundary of the rib-cage. Athena is shown in the guise of a *kore* with cumbersome *himation* over her arm.

Another Athenian work we owe to opponents of the dictator, the Alcmaeonid family led by Clisthenes, who is best known for his reconstruction of the Athenian constitution following the end

BELOW AND RIGHT
Athena and two Giants in battle, figures from pediment at Athens, 525–520

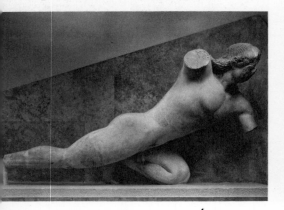

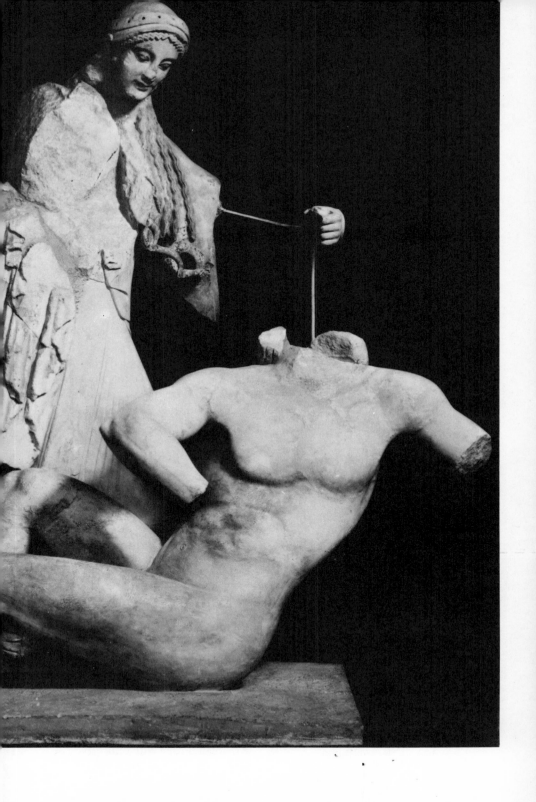

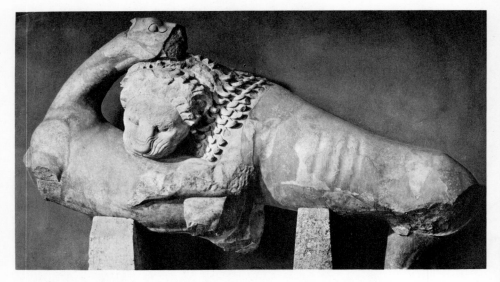

ABOVE AND BELOW Lion and deer, and *kore*, from a pediment at Delphi, 513–510

of the dictatorship. Exiled from Athens, the family sought to curry favour with the oracle at Delphi, whose political pronouncements carried religious sanction, by constructing at their own expense in the years 513–510 a marble facade to the new temple of Apollo there. It was a dull composition of frontal standing figures framed by animals in combat; but some of the carving is of excellent quality, notably the figure of a deer attacked by a lion (ABOVE), and a *kore* by the same sculptor as one on the Acropolis at Athens (LEFT: cf. p. 36).

A more attractive pedimental group comes from the temple of Apollo at Eretria, in Euboea (OPPOSITE). It represents Theseus carrying off the Amazon warrior Antiope over his shoulder. He captured her on an expedition to the land of the Amazons, and she eventually became his wife. But a punitive expedition of the Amazons followed, and Theseus retained his Athenian throne with difficulty. The

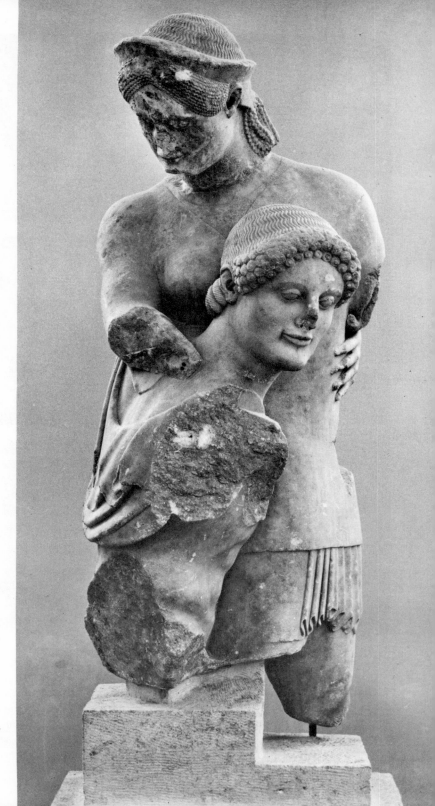

Theseus and
Antiope, part of
a pediment at
Eretria, *c* 500

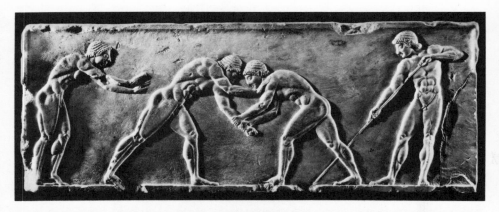

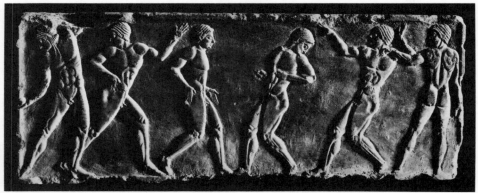

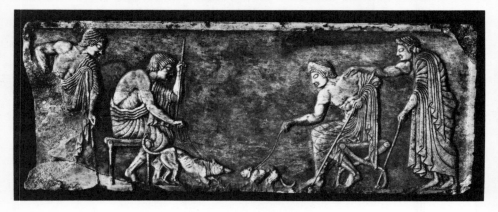

workmanship of this pediment also is surely Athenian of *c* 510–500.

Late archaic Athenian artists, of course, produced relief sculpture as well as statues in the round. Often their work recalls the spotlit compositions of contemporary red–figure vase paintings, where the figures are left in the natural colour of the clay against a black ground. Sometimes this impression is reinforced by the sculptor's use of dark paint for the background of his reliefs, as on a series

which decorated three sides of a square stone base which carried a statue, certainly of an athlete (OPPOSITE). On the front, two wrestlers practise holds while a runner practises the start and a javelin-thrower tests his missile. The side-faces of the block bear a ball game with six figures, and a cat-and-dog fight with spectators. The artist has not quite mastered the three-quarter stance of several of his figures: an oblique placing of the stomach muscle serves to convey foreshortening. But the individual details of anatomy are well observed, and the compositions are exceedingly varied and lively. The date is *c* 510–500, the first decade of democracy following the fall of the dictator. Ten or twenty years later, the Athenians erected a treasury, a small Doric temple-like building, at Delphi to celebrate their victory in the Battle of Marathon in 490, and to contain their more portable and precious offerings to the god. Its metopes were decorated with exploits of Heracles and of Theseus. One of the liveliest of the former shows Heracles killing the hind of Cerynia (BELOW). With his lion's skin knotted about his neck and his luggage parked behind him, the hero kneels on the animal's back and leans over to strike the fatal blow. Although the head is old-fashioned, the leg is extremely convincing, and the taut muscle of the stomach is divided correctly by only two transverse lines.

The last years of the sixth century saw a new restraint and simplicity in

LEFT Athletes, cat and dog fighting, on base for a statue, Attic, 510–500

RIGHT Heracles and the Hind of Cerynia, metope, Athenian treasury at Delphi, *c* 490

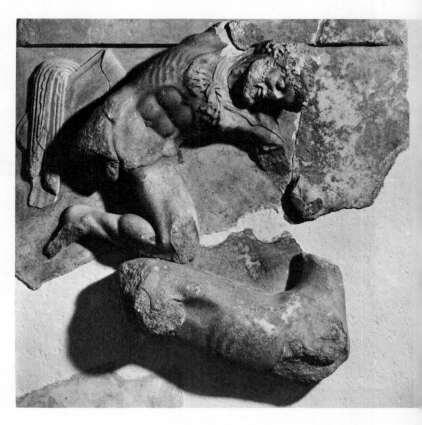

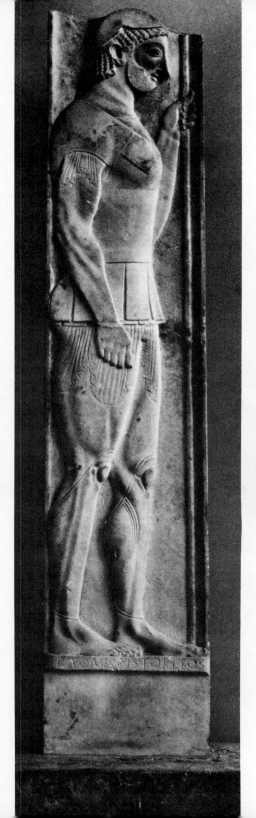

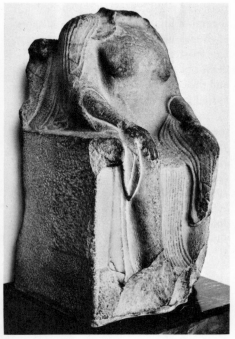

LEFT Gravestone of Aristion, Attic, c 510
ABOVE Seated figure from Didyma, c 520

RIGHT East side of 'Harpy Tomb'
from Xanthus, 500–490

tombstones, quite different from the grandiose monuments of the middle of the century and earlier (cf. p. 33). The prevailing fashion is for a much shorter shaft of *stele*, surmounted by a simple palmette between an Ionic double-volute, instead of the sphinx finial. One of the best is the *stele* of the soldier Aristion, signed by the sculptor Aristocles (FAR LEFT). Aristion is fully armed, with helmet, corselet, greaves and spear. The folds of his undershirt are not modelled but drawn on the flat surface; and they contribute to Aristocles' fine clarity of line. They illustrate too the love of surface patterning which reasserted itself in the late Archaic period.

We must leave the Athenian sequence: not all of the East Greek sculptors had emigrated to Athens. There was comparatively little employment to be found in the regions actually under Persian rule, but even here a few commissions could be won. The latest of the seated statues dedicated to Apollo at Didyma (LEFT: cf. p. 18) belong to the last quarter of the sixth century. One now feels that the figure could stand up and separate itself from its chair. The treatment of the legs contributes most to this advance. The East Greek seated statue becomes even more convincing early in the fifth century, as can be seen from the reliefs of the 'Harpy Tomb' at Xanthus in Lycia, south-western Asia Minor (BELOW).

But the best non-Athenian work was done away from Persian eyes, in the independent islands of the central Aegean. The treasury of the small but wealthy island of Siphnos at Delphi, built *c* 530–525, was a mass of ornament produced by island artists. Instead of columns, two *korai* supported its western

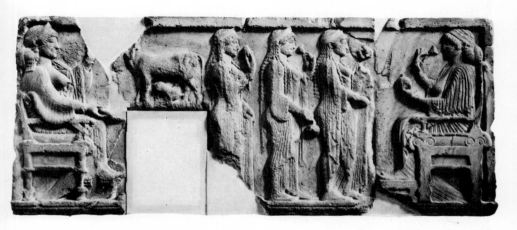

portico (cf. the Erechtheum Caryatids, illus. p. 116). The pediments were filled with sculpture. The glory of the building was its frieze, set above the architrave on the outside, with battles both of gods and giants, and of Greeks and Trojans watched by their supporters among the gods. One of the best scenes, on the northern side, shows the gods attacking from the left, the giants from the right (BELOW). At the left, the lame smith-god Hephaestus works the bellows to forge armour at his furnace. Two goddesses in front of him start forward to meet attacking giants. Heracles, in lion's skin, follows Cybele who rides in

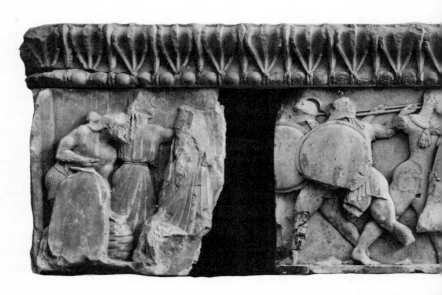

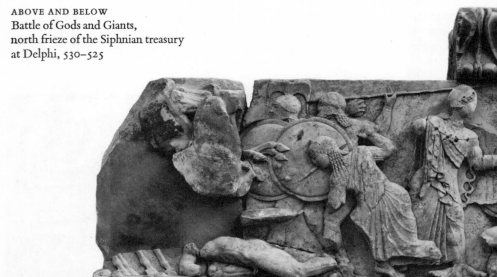

ABOVE AND BELOW
Battle of Gods and Giants,
north frieze of the Siphnian treasury
at Delphi, 530–525

her chariot drawn by lions, who seize
and maul a resisting giant. In front again
are Apollo and Artemis, advancing side
by side upon a giant who runs to take
shelter with three of his comrades
standing over a fallen fourth. The struggle
continues on the next slab (BOTTOM),
with Athena, Ares and other gods locked
in combat, and dead giants below.
The complexity of the composition is
remarkable; the artist was clearly one of
the greatest masters of his day. As usual
in archaic versions of the subject, he has
represented the giants as typical Greek
infantrymen. It was not until the
Hellenistic period that they took on the

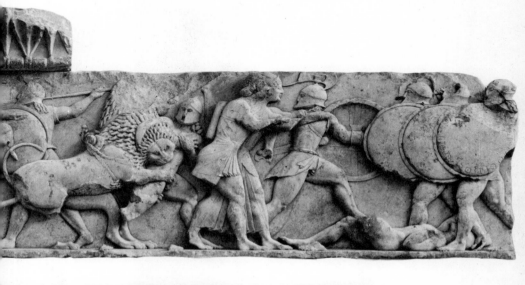

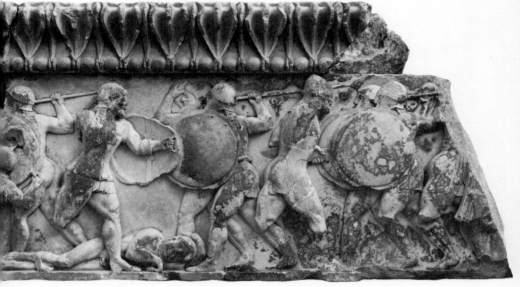

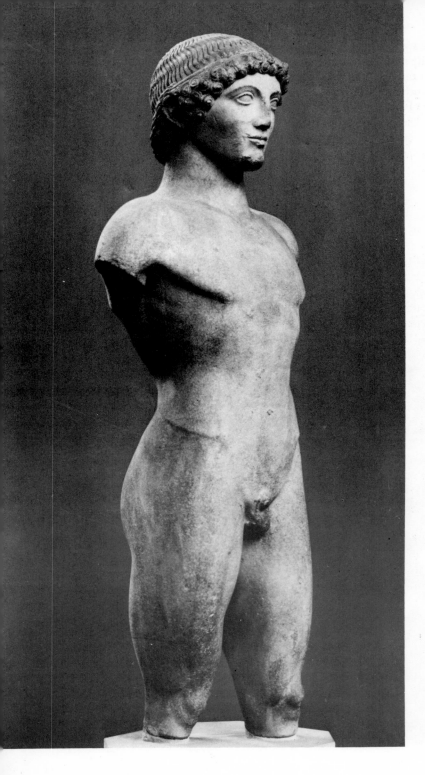

character of monsters (cf. pp. 164–5).

The island sculptors also produced *kouroi*, including the highly successful example formerly in the Strangford collection, and to be dated shortly before 500 (OPPOSITE). It was found on the island of Anaphe in the central Aegean. The bodily forms are softer than in most contemporary work at Athens, though no softer than in the Critian boy (p. 39). The real success of the figure is in the head, firmly and clearly modelled, with the eyes set well into their sockets and the mouth no longer twisted into an 'archaic smile'. One of the most original of the island artists, Alxenor of Naxos, carved a gravestone found in Boeotia (RIGHT). The old man stands in a relaxed pose, leaning on a knotted stick, attending to his playful dog. The dog is a common feature of grave-reliefs. The dead man is swathed in his *himation*, whose curved horizontal folds make an attractive contrast with the vertical lines of the composition itself. The relief is inscribed, 'Alxenor of Naxos made me: just look!' – a telling illustration of the growing self-consciousness as well as self-confidence of the artists of this generation.

Peloponnesian sculptors preferred a shorter, stockier figure than did the Athenians, islanders and East Greeks. Their finest work of this period is to be seen in the pediments of the temple of Aphaea (apparently the local equivalent of Athena) on the island of Aegina, *c* 500–480. There are remains of two east pediments: the earlier was evidently damaged soon after it was made, and replaced *c* 490. We are concerned only with the later eastern pediment, and with the western one. Both represented battle scenes, almost certainly the two Trojan Wars – Agamemnon's expedition against Priam (west) and Heracles' earlier campaign against Priam's father

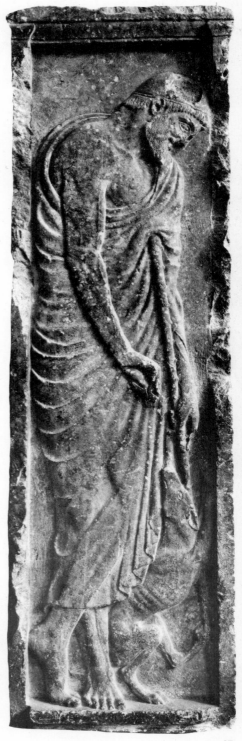

51

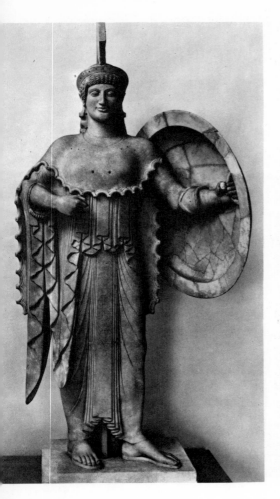

Laomedon (east), to which Aegina contributed respectively the great Ajax and his father Telamon. Athena occupied the centre of each pediment. In the western she stands armed and confident, as a *kore* with the *aigis* about her shoulders (LEFT). This was the terrible goat-skin bearing snakes for tassels and the head of Medusa, which Perseus had cut off (cf. pp. 17, 27). Holes show where the bronze Gorgon's head was attached separately, as were the snakes which formed its tassels. The goddess faces outwards, but moves slightly to her left. On either side were warriors engaged in combat, and dying figures in the angles (BELOW). The pose of the latter is unrelaxed, as if they were struggling with death. On the eastern side the scene was similar, though the figures are more supple and adventurous. Towards the right corner Heracles crouches, shooting with his bow, the Nemean lion's skin on his head for a cap (RIGHT). His muscles are powerfully shown, and the body reflects the tension of the bowstring. In the opposite corner a bearded warrior lies dying (RIGHT, BELOW). A comparison of this figure with the corresponding one in

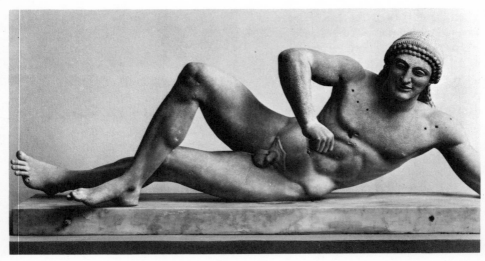

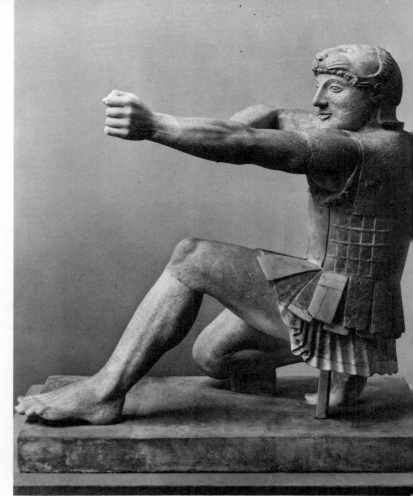

Figures from
pediments of
temple of Aphaea,
Aegina, 500–480
LEFT Athena and
dying warrior,
west pediment
RIGHT AND BELOW
Heracles and
warrior,
east pediment

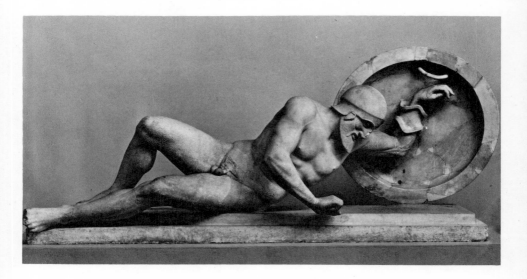

the western pediment will show how far towards naturalism the sculptors had moved in the decade or so which separates the two pediments.

Similar work was being done at Sparta. The powerfully built warrior popularly known as Leonidas, the hero of the battle of Thermopylae in 480 when his small Spartan force of three hundred delayed the whole Persian army, is in fact probably a few years too early for the identification to stand (RIGHT). The cheek-pieces of the helmet, in the shape of animals' heads, are an interesting feature.

The Western Greeks of Sicily and Italy continued to produce excellent work of an individual local character. Related to East Greek sculpture, and especially to the Harpy Tomb from Xanthus (illus. p. 74), is the seated goddess from Taranto or Locri (OPPOSITE). She is probably a cult statue, sitting regally with arms extended in a gesture of welcome to her worshippers. The relation of figure to throne is happily worked out.

By the end of the sixth century successive concepts of beauty – geometric analysis, daedalic orientalism, archaic patterning – had been continually modified by contact with the real world, to the point where a generalized naturalism (not realism) had been reached, and a credible impression of movement could be given in free-standing as well as in relief sculpture.

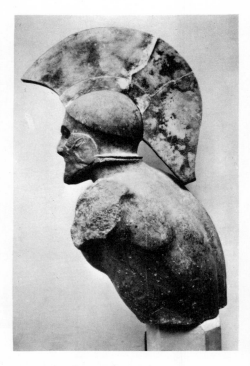

ABOVE Spartan warrior, 490–480

RIGHT Seated goddess, from Taranto or Locri, c 480

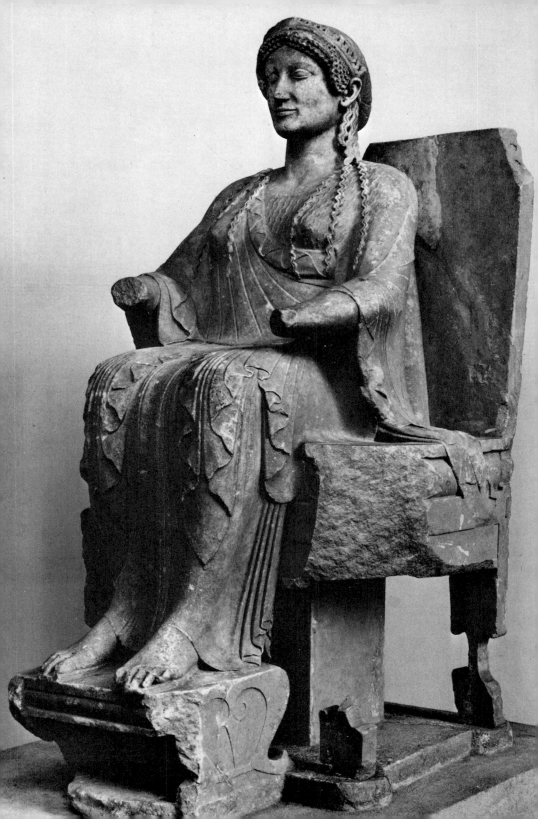

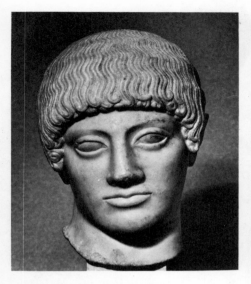

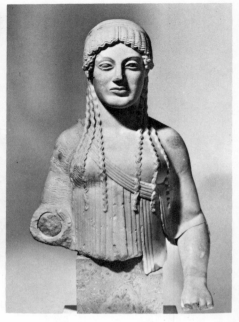

ABOVE Blond head, Attic, *c* 480
RIGHT *Kore* (No.686) dedicated by
Euthydicus, Acropolis, Athens, *c* 480

Since Athens was by now the undoubted
leader, we may sum up this achievement
in three Athenian works from the
Acropolis, all very close to the year 480
when they were overthrown by the
Persians and buried there: the Critian
boy (p. 39), a blond head (ABOVE), and
a *kore* dedicated by Euthydicus (ABOVE,
RIGHT). Janus-like, the three both
sum up what has gone before and look
forward – the Critian boy to the

Tyrannicides and the charioteer of
Delphi (see pp. 58, 61), the two heads
to the Apollo at Olympia (see p. 79).

In much of this Late Archaic work,
attractive as it is, there is an air of
unreality, of the calm before the storm.
Politically, the storm broke in 490 and
again in 480, when mainland Greece was
invaded by Persia and the Greek West
by Carthage. The artistic storm
followed closely.

4 The Transitional Period
c 480-450

The archaic period of Greek history ended with the failure of two attempts by the Persians to overrun Greece. In 490 the Athenians defeated the armies of Darius at Marathon. Ten years later, 480–479, the Athenian fleet played the major part in the defeat of Xerxes' navy at Salamis and Mycale (on the coast of Asia Minor, opposite Samos), while the Spartans and other allies defeated the Persian armies at Plataea. Though hostilities were pursued for a generation by many of the maritime states of Greece under the leadership of Athens, never again was there any real threat of invasion. But the vast dangers and destructions of the Persian Wars led to the final dissolution of the old aristocratic basis of Greek society. The changes which Greece underwent in the generation 480–450 were at least as great as the changes in our own society in the comparable period 1914–1945. Everywhere old conventions were questioned, new experiments tried, not least in the field of art. The Persians had destroyed innumerable temples and statues, especially at Athens, where under the leadership first of Themistocles and later of Pericles it was decided to sweep away the old without any attempt at restoration, and to build a new city. Ruined temples, overturned dedications, all were used unsentimentally as a quarry for the new walls of defence.

The reconstruction of Greece was a splendid opportunity for new artists, and the prevalent style of this 'Early Classical' or 'Transitional' period is quite different from the formalism of the archaic artists. Their mannered surface patterns were swept away: a broader treatment of plain surfaces became the fashion, the goal a greater fidelity to nature.

The major sculptors of the period worked in bronze rather than marble. (Our heavy dependence on Roman marble copies is due to the loss of the originals through remelting of this valuable metal.)

It may be suggested that the facility with which clay and wax models could be created for the foundry, and the comparative ease of alteration and correction in these materials, encouraged a generation already self-confident as a

BELOW Portrait of Themistocles, from an Attic original of 480–470, manner of Critius and Nesiotes

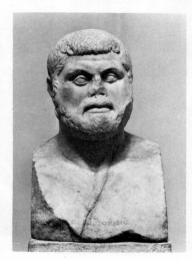

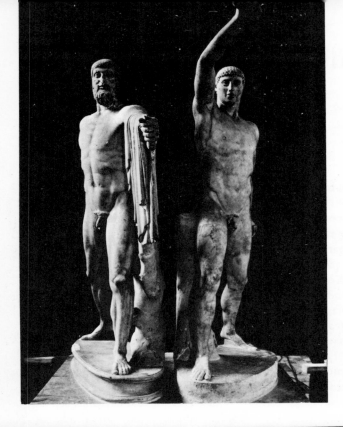

Harmodius and Aristogiton,
from originals of Critius
and Nesiotes, 477–476
LEFT Copies in Naples
BELOW Composite casts,
corrected from other copies

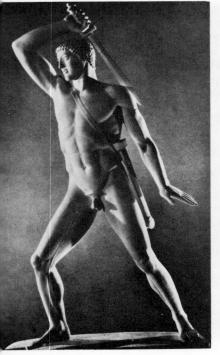

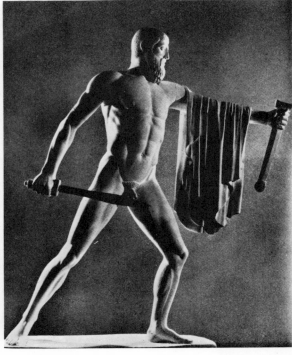

result of the recent victories to cast any lingering caution to the winds. Certainly it was an age of experimentation, in the display of violent action, and in the first development of individual portraiture.

Archaic, especially late archaic, *kouroi* and *korai* occasionally seem individual. But the earliest identifiable true portrait is that of Themistocles, known from a Roman copy found at Ostia (p. 57). Much of the modelling is of the conventional style of the period. But in this pugilistic countenance, no vision of ideal beauty, we see the genuine face of the man to whom belonged the chief credit for the rout of the Persian emperor and his vast armament. The original appears to have been an Athenian work, done from the life before Themistocles' disgrace and exile *c* 471. For the style is very close to that of Aristogiton in one of the earliest compositions of the period, the Tyrannicides.

This group, of Aristogiton with his young friend Harmodius, was completed in bronze by the sculptors Critius and Nesiotes in 477/6, to honour the memory of the two men whose assassination of the dictator's brother in 514 had earned them the credit for the destruction of the dictatorship itself when it fell four years later. The statues replaced a version of the same subject by Antenor, looted by Xerxes when he sacked Athens in 480. Even in the Roman copies (LEFT) we can see the gulf which separates the new style of Critius and Nesiotes, clear and confident in the treatment of anatomy and movement, from the serene but timid work of the pre-war world. The two men advance side by side, the elder extending his cloak to shield his friend, who prepares to strike the first blow.

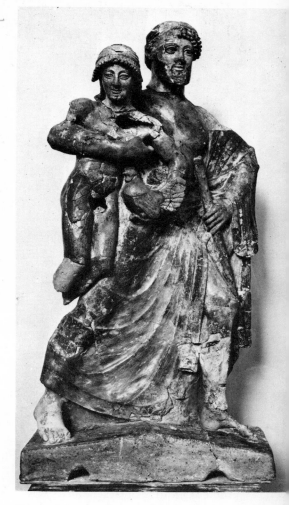

Zeus and Ganymede, terracotta, at Olympia, 500–475

A very few years later, a terracotta group of Zeus carrying off the Trojan princeling Ganymede to be his cup-bearer was dedicated at Olympia (ABOVE). Of Peloponnesian workmanship, it was probably an *akroterion*, the decorative feature surmounting a pediment, to judge from the shape of the base. Zeus hurries home to Olympus, purposefully grasping his knotted staff and with his cloak supported

over his left arm. Ganymede appears to
be floating along contentedly, gripping in
his left hand the cock with which Zeus
has bribed him.

Violent motion was not universal,
however. It might have been expected
that the victory of Polyzalus (viceroy of
Gela under his brother the tyrant of
Syracuse) in the games at Delphi in 478
or 474 would be commemorated by a
bronze chariot-group at full gallop.
Instead, the charioteer stands erect,
parading at a walk after the victory or
before the start (OPPOSITE). His feet and
the column-like lower part of his body
point in the direction of motion, but the
head is turned to the right, carrying the
chest with it, towards the spectator. The
statue was cast in several pieces and the
joins concealed by edges of drapery. The
head – which shows the peculiarly Early
Classical love of the straight 'Grecian'
profile as a feature of ideal beauty – was
finished by hand, details being chased in
the cold bronze. The side-curls and
eyelashes were made separately, the eyes
inlaid to add a touch of realism (RIGHT).
The sculptor is unknown, for a base-block
with the signature of Sotadas of Thespiae
probably does not belong. The full forms
of the face, especially of the heavily
rounded chin, suggest a local sculptor of
the Greek West – a Sicilian or a south
Italian.

The same quietness can be observed
in other sculpture from the West.
The metopes of the Temple of Hera

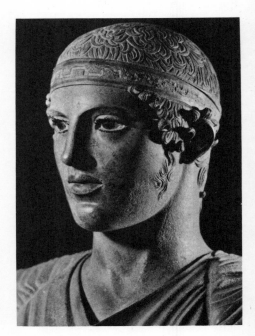

ABOVE AND OPPOSITE
Bronze charioteer, Delphi, c 474

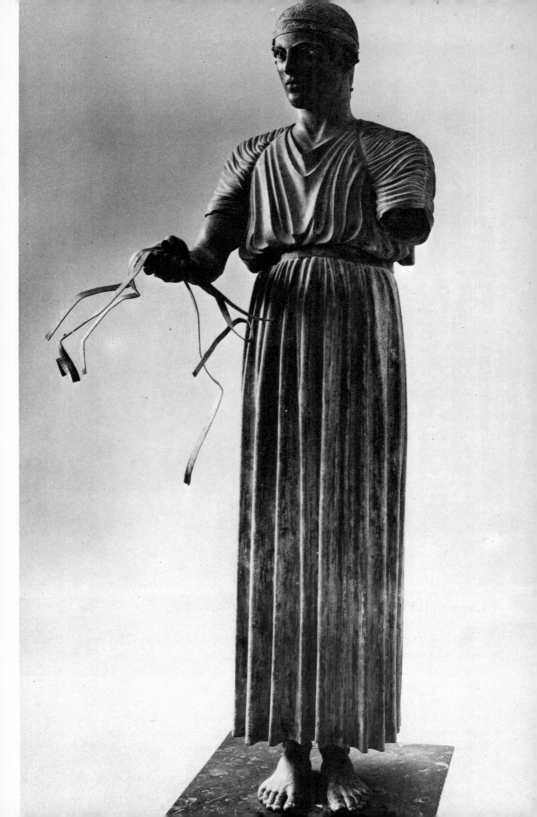

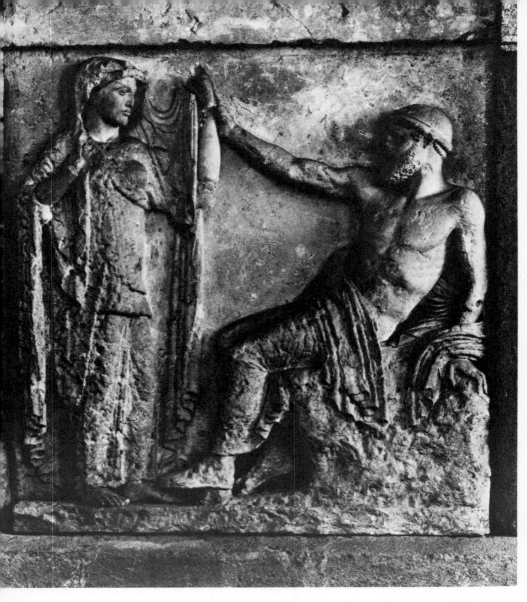

Zeus and Hera, metope from Selinus, 475–460

('Temple E') at Selinus in south-western
Sicily were carved c 475–460. We look
at two, from the east end of the temple.
On one, the bride Hera unveils herself
before Zeus on Mount Ida, while her
eager husband, his eyes meeting hers,
stretches out his right hand to draw her
to him (ABOVE). The archaic formalism

of drapery still persists. On the other
metope, Artemis punishes the hunter
Actaeon for his presumption in falling in
love with a favourite of Zeus, by dressing
him in a stag's skin so that his own dogs
mistakenly attack and kill him (RIGHT).
The stag's front legs can be seen hanging
down in front of Actaeon, its head and

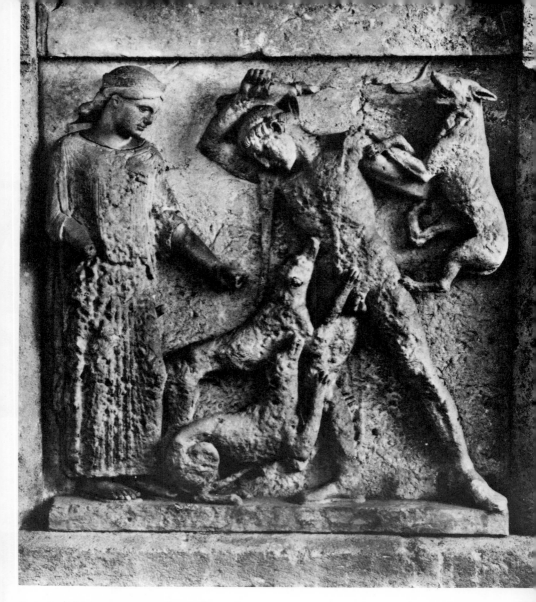

Artemis and Actaeon, metope from Selinus, 475–460

antlers appear above and behind his own head. Certainly there is violent action here, especially in the way in which Actaeon raises his right arm to strike one of the dogs. But the western quietness is evident in the gentle encouragement which Artemis gives the hounds. On both these metopes, the naked parts of

the female figures are inlaid in Parian marble. Otherwise the material is local volcanic tuff, which has weathered badly. This, of course, was originally painted.

A series of reliefs which perhaps surrounded the sacred pit of Persephone, Queen of the Underworld, at Locri in south Italy are among the finest works of

the period c 465. There are two three-
sided pieces. The better, the Ludovisi
'throne' in Rome (ABOVE), shows on its
main panel the goddess arising out of the
earth, with two attendants to conceal the
apparition behind a veil. (The subject has
also been thought to be Aphrodite
emerging from the sea, her attendants
standing on a pebbly beach.) On the sides,
a nude flute-girl and a heavily veiled
woman burning incense. The
compositions are charming and successful,
and we have to look twice to see the
extraordinary anatomical errors, in
Persephone's breasts, in the scale of the
further arms of the two attendants, and
in the right leg of the flute-girl which will
need considerable contortion out of sight
if it is to be attached to her body. The
drapery, however, is beautifully carved,
with the folds in extremely low relief.
The companion 'throne' is in Boston
(BELOW). Here the subject is obscure:
perhaps winged Death (cf. p. 140)
weighing the spirits of two mortals in the
presence of one happy and one sorrowing
patron goddess. On the sides, again one
nude figure, a lyrist to face the girl
flautist, while a wrinkled old woman
observes the incense burner. The upper
edge of each 'throne' was originally
horizontal; the sloping surfaces are later
alteration. Clearly, both sets of reliefs
follow a single composition; but the
sculptor of the Boston 'throne' has much
more sense of the third dimension, much
less charm of execution.

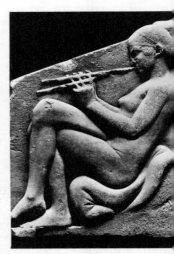

'Ludovisi Throne', 480–470

'Boston Throne', 480–470

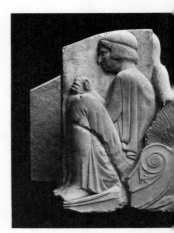

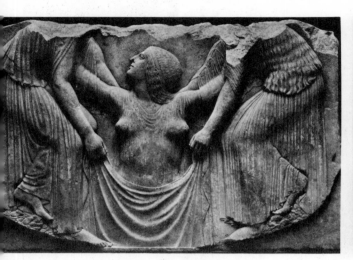

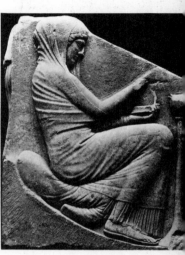

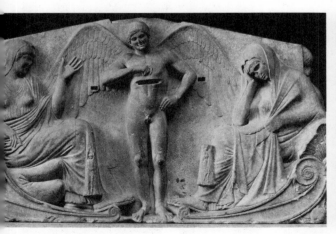

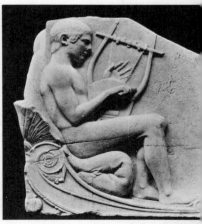

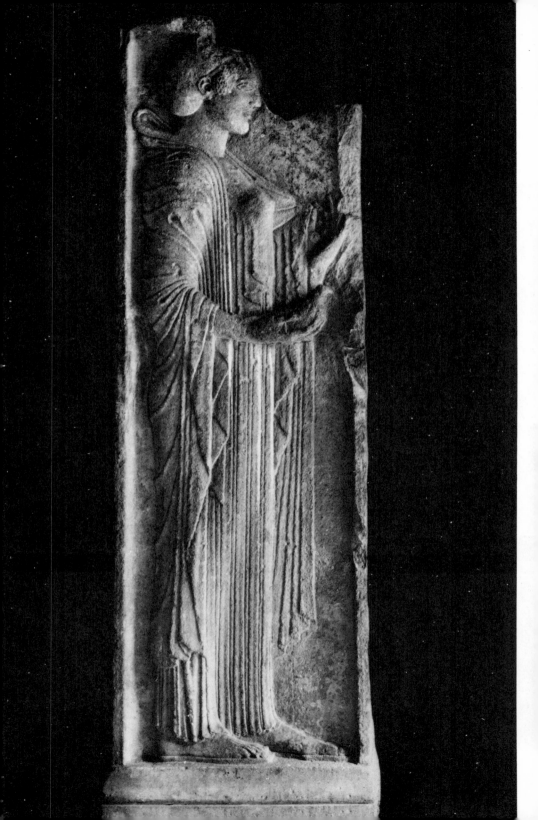

From the same artistic circle, and perhaps also from Locri, we have the sepulchral *stele* of a tall girl carrying a dove (OPPOSITE). She wears *chiton* and *himation*, with her hair in a net. There is still a good deal of formalism about the folds, the *himation* recalling the Berlin goddess (cf. p. 55), the tunic the Delphic charioteer (cf. p. 61). The Locrian provenance is suggested by the many resemblances between the *stele* and locally made terracotta plaques.

LEFT *Stele* from the Esquiline, Rome, *c* 470

At the other end of the Greek world we may look at two works from Xanthus in Lycia. The first (BELOW) is part of a frieze of chariots and horsemen, which seems, incidentally, to show that riding-horses were a larger breed than those which pulled chariots. The date is *c* 470. Archaic formalism, however, is still evident in the folds of the short tunic worn by the groom, and in the treatment of eyes, nostrils, and necks of the horses. The second work from Xanthus is rather

BELOW Horses and grooms: frieze from Xanthus, *c* 470

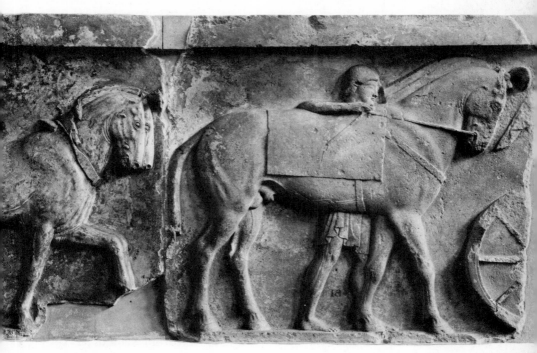

ABOVE *Kore* from Xanthus, 470–460

OPPOSITE Heracles, Atlas and
the golden apples: metope from the
temple of Zeus at Olympia, 470–457

later, perhaps *c* 460, a standing female
statue (LEFT). It shows the tendency
towards broad expanses of flat cloth and
flattened folds which we shall observe in
the Olympia metopes which follow
next. The dress is the *peplos* (cf. p. 35).

The temple of Zeus at Olympia is the
greatest monument of this generation,
rapidly built in the period *c* 470–457, and
eventually the home of Phidias' colossal
statue of the god (see pp. 92–3).
Fully described by Pausanias, its
sculptured decoration consists of marble
pediments and metopes, the latter
confined to the eastern and western ends
of the *cella* itself, within the colonnade.
The subject of the metopes is the Labours
of Heracles. We look at four of the best.

First, Heracles supports the universe on
his shoulders while Atlas, whose normal
duty it is, fetches for him the apples from
the garden of the daughters of the
Evening Star (RIGHT). The weight of
this burden, though made less
uncomfortable by a folded cushion,
nevertheless causes the hero's body to
bow outwards in front. Now the
exchange is to be made, while Athena
briefly holds the universe from falling,
using one hand only and with her weight
resting carelessly on her left leg only. No
sign of effort appears; what is hard for a
mere hero is easy for a goddess. The
appearance of the two men recalls the
eastern Aegina pediment (cf. illus. p. 53).
The drapery of Athena may be compared
with the *kore* from Xanthus (LEFT).

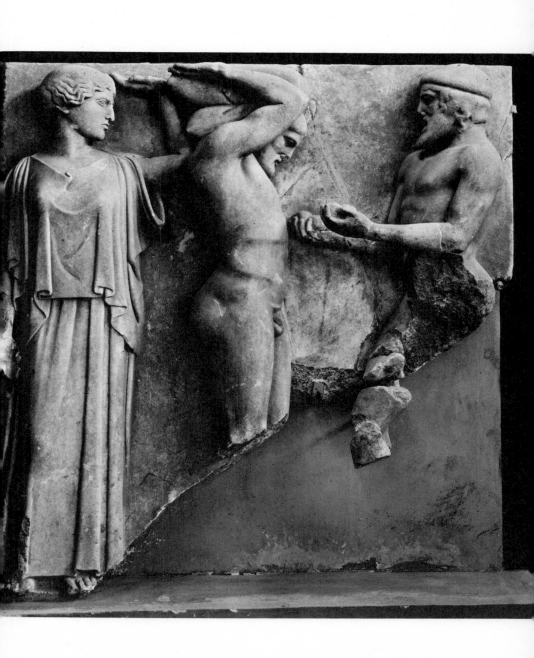

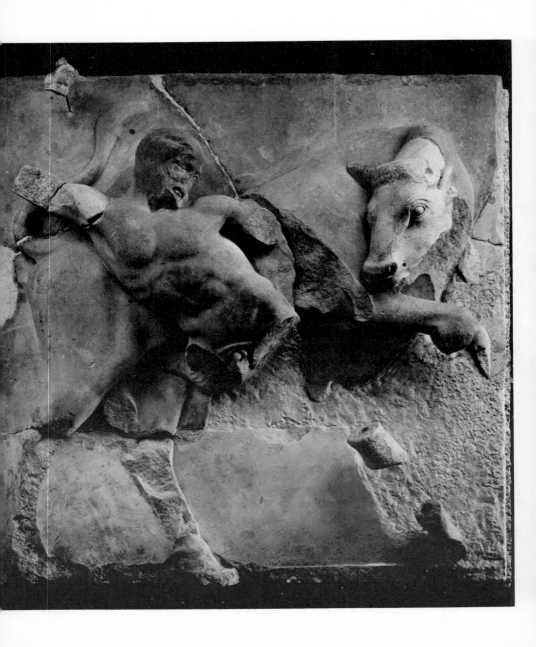

In the second metope, Heracles is fighting the bull of Cnossus (LEFT). The animal turns its head to lunge and gore the hero. But he is too quick and has already retired out of reach, his weapon held aloft in his right hand, to deliver another blow. The violence of the deed is well conveyed by the predominantly diagonal lines of the composition, and the way in which the wary eyes of animal and hero meet as they turn their heads back. The same device of the cross-composition is employed in the third metope, of Heracles swilling the dung from the stables of Augeas (p. 72). As he labours to create a flood by breaching the river-bank with his long crow-bar, its handle crosses his own body which is leaning forwards in the opposite direction. Athena stands by and assists the hero by indicating the weakest point with her spear (now lost: originally a bronze addition). Lastly, Heracles brings the goddess the man-eating birds of Stymphalus (p. 73). (The birds do not survive.) Athena, unarmed except for her *aigis*, turns almost shyly to receive them. Heracles is in a relaxed pose, the strenuous task accomplished; and the sculptor has succeeded admirably in conveying the three-quarter view. Athena sits on a rock, precariously balanced, supported by her left hand and the steady pressure of the toes of her right foot. For its observation of the relaxed human form, this metope has few equals of its period.

Metopes from the temple of Zeus
at Olympia, 470–457:
LEFT The Cretan Bull

OVERLEAF:
LEFT Cleansing the stables of Augeas
RIGHT Athena and the Stymphalian Birds

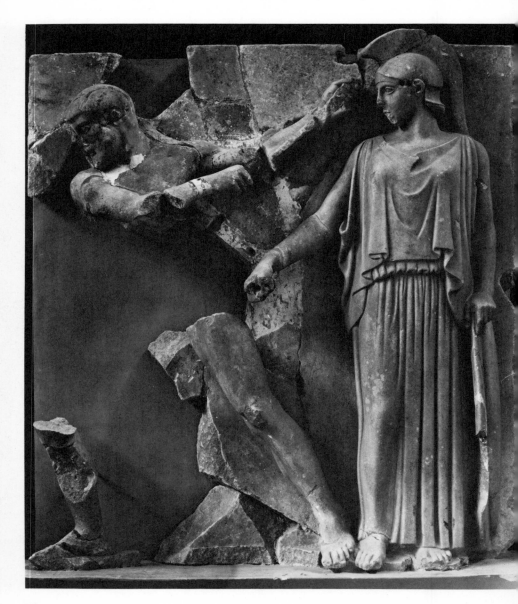

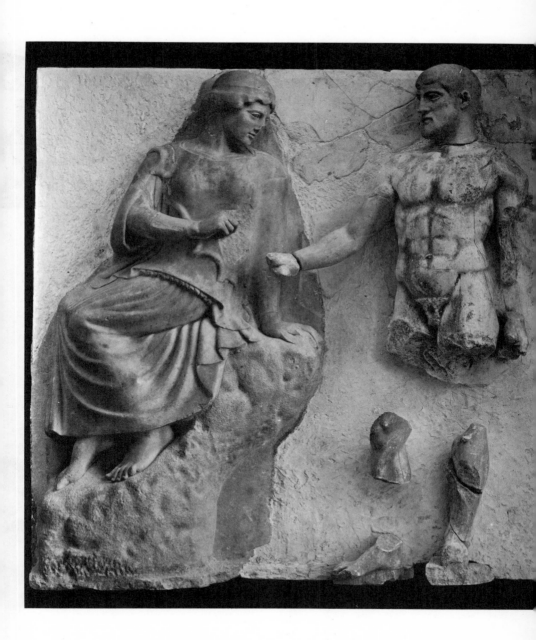

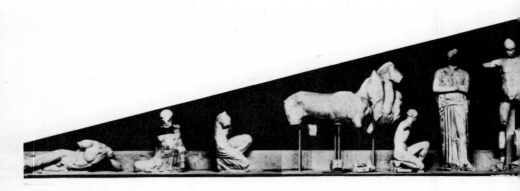

ABOVE East pediment, temple of Zeus at Olympia, 470–457

The two pediments of the temple at Olympia are very dissimilar in composition. The eastern (ABOVE) carries a symmetrical series of standing individuals not interlinked in action. It is an old-fashioned arrangement, echoing the east pediment of the temple of Apollo at Delphi, of *c* 513–510 (see p. 42), and certainly obsolete since the Aegina sculptures (see pp. 52–3). By contrast, the western pediment (BELOW) is all riotous action, of figures which, though arranged in broadly balanced groups, convey above all an impression of a single interlocking mêlée.

The east pediment (details overleaf) takes a theme popular in Early Classical sculpture, the moment of calm before the storm. The subject is the legendary chariot race between the Asiatic intruder

BELOW West pediment, temple of Zeus at Olympia, 470–457

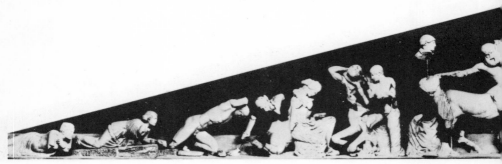

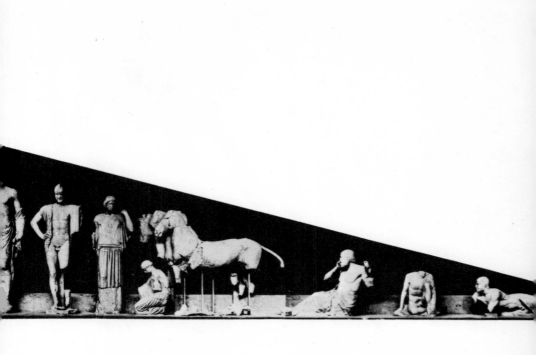

Pelops and the local king Oenomaus, to decide whether the former might marry the latter's daughter. Earlier suitors had failed and paid the penalty of death. But the daughter, Hippodamia, fell in love with Pelops and so bribed her father's charioteer to disable his chariot. Pelops won the race – and the girl. The whole pediment shows the scene just before the start of the race. In the centre, Zeus towers to more than mortal height unseen by the contestants; on one hand, Pelops and Hippodamia, on the other Oenomaus and his queen; then the two chariot-teams, in the centre of each wing, with a groom kneeling in front of one and a serving girl in front of the other; in the angles, crouching and reclining spectators. Sculpturally the most interesting are three figures from the

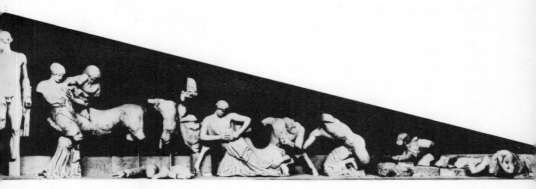

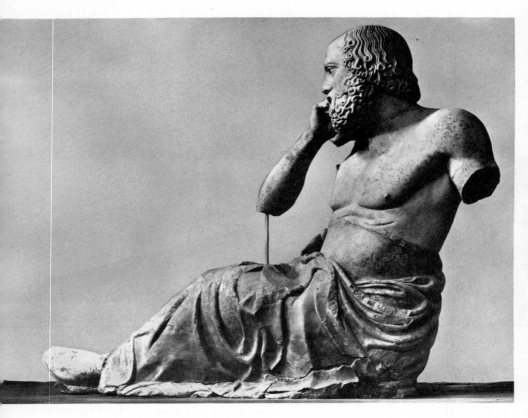

angle at the right shown here:
immediately behind the chariot,
a seated seer; then a seated youth of
unknown identity facing to the front;
then a reclining figure who eagerly
cranes forward to watch, to be identified
as the local river-god Cladeus. The flat
folds of the drapery recall the metopes.
The anatomical detail, though summary,
is convincing: the flabby chest of the old
seer, the strikingly original and difficult
pose of the youth, the tension in the chest
and belly of Cladeus and in his neck and
triceps. In their treatment of these figures,
and of the whole pediment, the artists
were always aware of the special demands
of sculpture high on a building, which
will never be seen from close at hand. All
the forms, of anatomy as well as drapery,
are exceptionally bold and uncluttered.

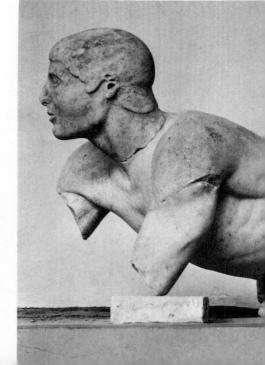

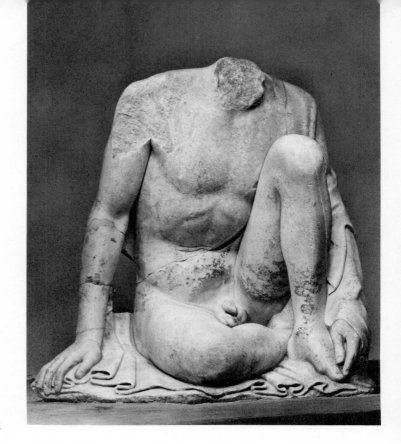

Details of
east pediment:
LEFT Seer
RIGHT Seated
youth
BELOW River-god

The scene in the west pediment seems
to have been derived from a mural
painting in a new shrine of Theseus at
Athens, constructed in 476/5. Presided
over by Apollo with right arm extended
(OPPOSITE), the subject is the combat
between the Lapiths and the Centaurs.
On the occasion of the marriage of
Pirithous king of the Lapiths in Thessaly,
the Centaurs their half-horse neighbours
became drunk and tried to carry off the
Lapith women and boys. With Apollo's
help and with that of Pirithous' friend
Theseus of Athens, they were at last
defeated and driven off. The subject was
a popular one in the fifth century—we
shall meet it again in the Parthenon and
at Phigalia (cf. pp. 96–9, 122–3) –
because it seemed to symbolize the
struggle for the survival of Greek
civilization against barbarism, recently
repeated in the Persian Wars. Here
Apollo is the only vertical single figure,
the others all being united in interlocking
groups. The placing of the figures is a
matter of considerable uncertainty.
The Lapith woman resisting a Centaur
certainly did not, as here, stand immed-
iately next to Apollo, who was in
fact flanked by Pirithous and Theseus.
Apollo is comparatively relaxed –
reminding us, as does the Atlas metope,
that what is hard effort for a mortal is
easy for a god. Apollo's idealized head is
particularly fine, in the modelling of
brow and mouth, and of the still rather
archaic hair. In a group from the left side

Detail of west pediment:
Apollo, with Centaur and Lapith woman

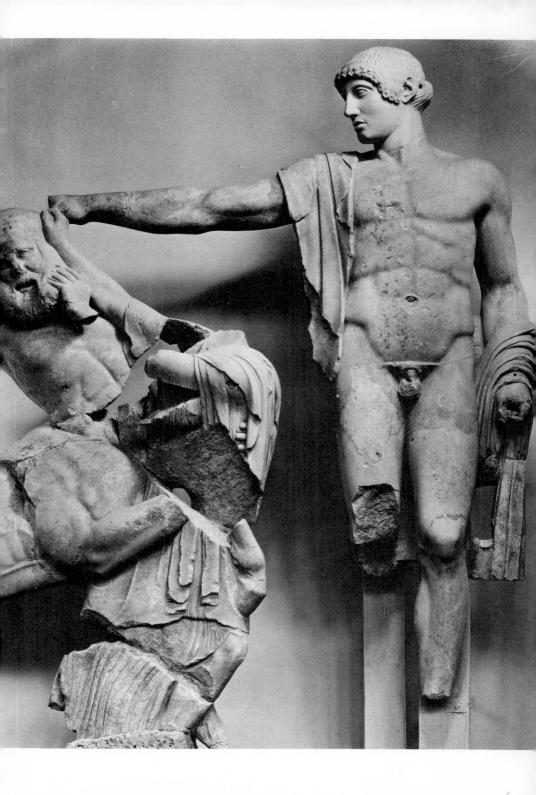

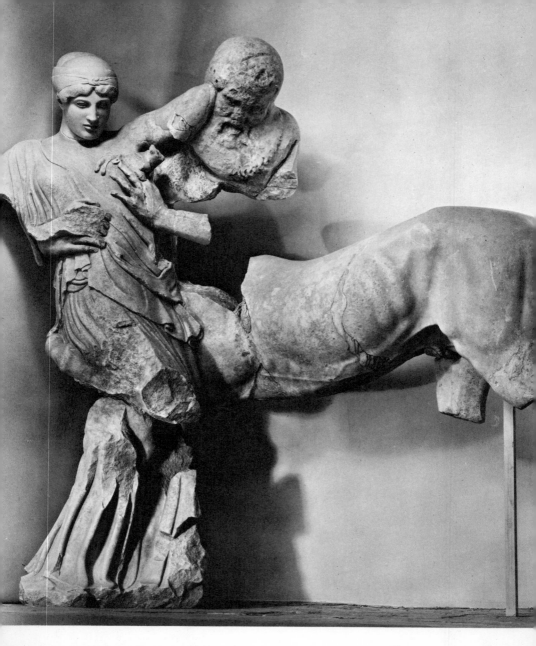

we see Pirithous' bride herself attacked, firmly grasped by the Centaur even though she tries to elbow him away (ABOVE). Her head seems to be by the same hand as that of Apollo. From the right half, a Centaur bites the arm of a Lapith who struggles with him, losing his cloak in the process (OPPOSITE). The pain of the bite is expressed in a pair of wrinkles on the Lapith's forehead. Otherwise only the Centaurs' faces show emotion. The Lapith's hair is an interesting compromise between Apollo's archaic 'snail' curls and the newer

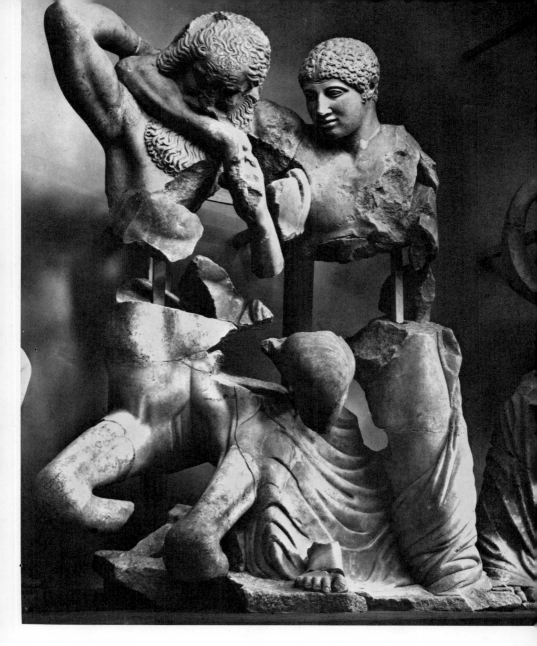

Details of west pediment:
LEFT The bride seized by a Centaur
ABOVE Centaur biting Lapith boy

fashions becoming current. In all these figures, although they were placed high up in a pediment, there is a high standard of finish in the execution: even toe-nails and finger-nails are carved with care.

We turn again to free-standing sculpture. One of the most remarkable

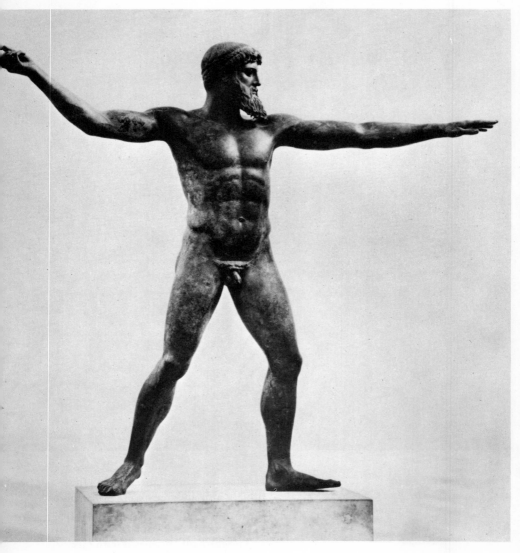

ABOVE Bronze god from Artemisium, *c* 460
RIGHT 'Apollo', after an original of 460–450

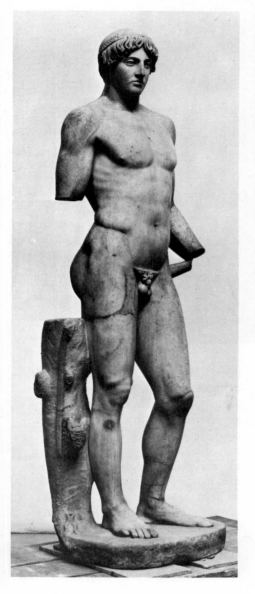

survivors is the bronze god found in the
sea off northern Euboea (FAR LEFT).
The god is shown in athletic middle age,
the tense muscles modelled with great
power, as he concentrates his gaze on the
target and prepares to hurl his weapon.
But what is the weapon? Many
authorities see here the sea-god Posidon
throwing his deadly trident. But the long
three-headed spear would obscure the
god's face and so spoil the composition.
Moreover the pose is well-known in
bronze statuettes of Zeus hurling his far
shorter weapon the thunderbolt, and that
is likely to be the true identity in this case
also. The date is *c* 460. The sculptor must
have been one of the great masters of the
period: we have the names of several, but
real knowledge of the style of only one
or two, and it is fruitless to attempt any
attribution.

An outstanding athlete statue of the
same period is known from Roman
copies, notably the so-called 'Apollo' on
the Omphalos in Athens and the Choiseul
Gouffier replica in London (LEFT). The
original was of bronze, hence the addition
of the tree-stump support, necessitated
by the copyist's use of the more brittle
medium of marble. The victor stands
proudly, his weight on the right foot and
the right hip thrown out. The muscles
here are subtly suggested rather than
depicted in detail, as they were in the
bronze god. The modelling of the head,
with its clear lines, recalls the Apollo at
Olympia (cf. p. 79); but the face shows

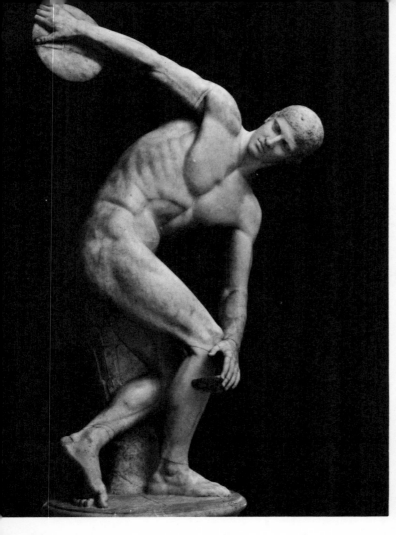

Copies of
originals by
Myron, *c* 450:
LEFT
Discus-thrower

RIGHT
Athena and
Marsyas

considerably more expression. The
'free-standing' treatment of the hair is
characteristic of modelling for bronze
(cf. Zeus, p. 82), and is a considerable
advance on the hair of the charioteer at
Delphi (cf. p. 60).

We end this period, as we began it,
with the work of a known artist at
Athens identified from Roman copies
and from references in ancient literature.
Myron of Eleutherae on the borders of
Attica and Boeotia was the greatest
sculptor of his day, working almost
entirely in bronze. A Roman writer,

Petronius, describes him as 'able almost
to imprison the life of men and beasts in
bronze'. He was a bold innovator,
experimenting with a variety of novel
poses, yet had not quite mastered the
third dimension in that his figures have
a frontal plane swinging this way and
that, to which side planes are attached
without the smooth transition which
marks the increased naturalism of later
work. Myron's two most important
works are the Discobolus and the Athena
with Marsyas. The first shows the discus-
thrower in the act of making his cast – the

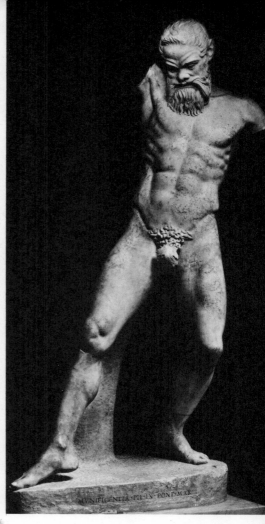

stationary moment at the end of the
back-swing before he whirls round and
hurls his missile (LEFT). The shoulders
are virtually frontal, the legs in profile.
The transition is anatomically obscure,
but artistically convincing. The small
close locks of hair are characteristic of the
period, *c* 450. Myron's other important
work was a group standing on the
Athenian Acropolis and made at about
the same date. Athena, with helmet and
spear, has just thrown away a pair of
flutes, having found that the puffed
cheeks necessary to play them added

nothing to her beauty. The satyr Marsyas
comes forward curiously to pick them up
(ABOVE, LEFT AND RIGHT). But the
goddess warns him off with a threatening
gesture, and the satyr starts back raising
his right arm in self defence. The pose of
starting back is a new one in free-standing
sculpture (though that of falling forward
was already attempted in the Aegina
pediments), and here again we see the
great innovator at work. The satyr's
fright is well shown in his furrowed
forehead; and the device of placing one
leg in profile and the other frontally

85

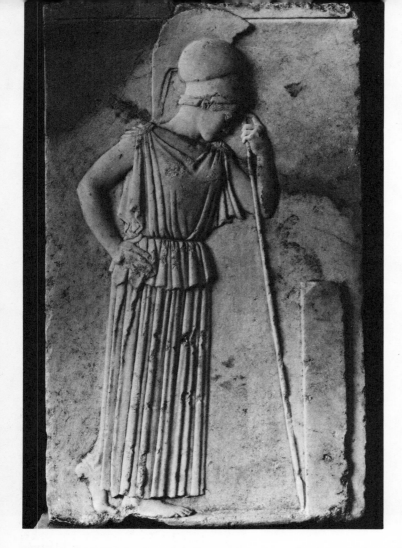

'Mourning
Athena', *stele*,
Attic, *c* 450

adds much to the liveliness of this
instantaneous pose.

It must have been a sculptor who had
seen this group by Myron who was
responsible for the charming relief of
Athena from the Acropolis (ABOVE). The
goddess leans on her spear, contemplating
an inscribed stone *stele*. What was
written, we cannot know: perhaps a
casualty list, which would account for the
attitude of the 'mourning Athena'.
Though the goddess's body slants, the
folds of her dress follow its line and do
not hang vertically. The artistic effect is
preferable. But it shows that the sculptor
does not yet aim at the greater naturalism
of the fully Classical period, to which we
now turn.

5 Classical Idealism
c 450-380

The next period covers the second half of the fifth century and the early years of the fourth – say 450–380 BC. In terms of original sculpture which has survived, it is almost entirely a period of architectural adornment, designed by great artists but often executed by lesser. But the masters certainly produced free-standing statues in large numbers, for the most part in materials other than stone, and of these many Roman copies have survived. As in the previous period, their favourite material was bronze. But a number of ostentatious works, largely cult statues, were ordered in a technique known as chryselephantine: upon a wooden frame the flesh was overlaid with ivory, the drapery with gold. The most famous of these statues were both by Phidias, the Athena Parthenos at Athens and the Zeus at Olympia.

Politically the period is marked by the pre-eminence of Athens. Within a decade after 450 Athens made herself the indisputable mistress of the Aegean, having already enjoyed a generation of leadership of the maritime states in pursuit of the war against Persia. The islands and coastal towns who now exchanged alliance for subjection paid to Athens a considerable annual revenue for collective defence, and it was out of this money that the Parthenon and other buildings and adornments were dedicated to the gods – an act of conversion whose fraudulence did not escape the condemnation of the opposition party at the time. Throughout the crucial years in which her empire was consolidated, Athens was governed by Pericles practically as dictator, working through the formal processes of democracy; and to him alone belongs the credit or the blame for initiating the great programme of public works. With all this lavish expenditure of public money, we shall not be surprised that Athens was the chief artistic centre of the time.

Pericles, after an original by Cresilas, c 440

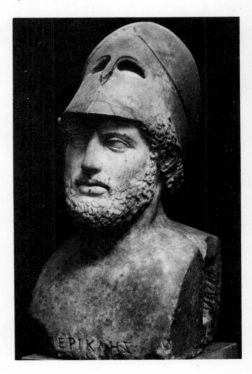

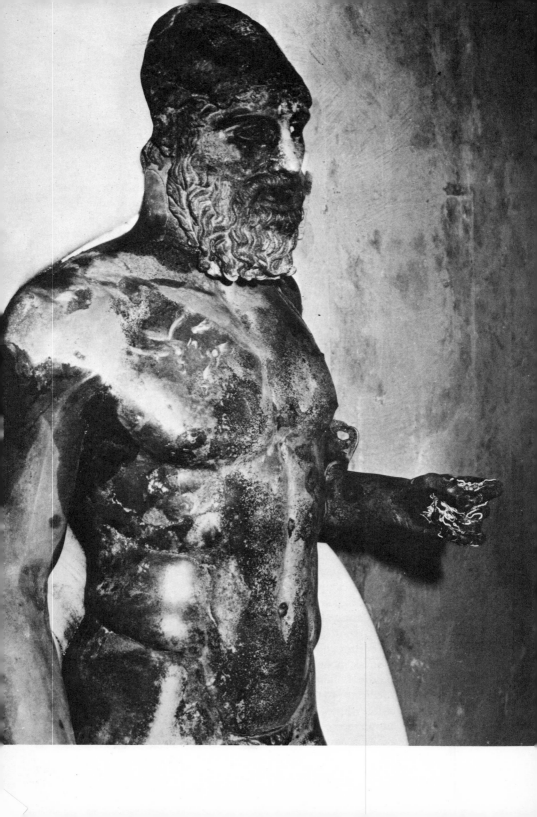

Of Pericles himself many portraits were produced. The most popular has survived in Roman copies (p. 87), and is probably after an original by Cresilas dedicated on the Acropolis. It stirred Pliny to comment, 'The remarkable thing about this art is that it has made men of renown yet more renowned'. Pericles wears a helmet to symbolize his constitutional position as general, but raised off his face in the non-combative position. The high dome of his head was a famous feature; and we see it through the eye-holes of the helmet. Characteristic too must have been the slight tilt of the head, which seems to give individuality to this idealized 'Olympian' portrait. The composition is balanced by the tilt of the helmet in the opposite direction. The original will not have been a mere bust: that is a Roman form (cf. the copy of Themistocles, p. 57). The Greeks looked for an expression of character in the whole body, not only in the face. Cresilas' statue will have been a complete figure, nude but for the helmet and holding shield and spear. A full-size original bronze statue, one of two recently recovered from the sea off southern Italy, provides a nearly contemporary parallel (OPPOSITE). The figure stands in an easy pose, and once held a spear and a shield. The treatment of the beard recalls Cresilas' Pericles; and there is every likelihood that this is a mainland work, perhaps even a portrait of one of Pericles' colleagues, looted in

Bronze portrait of a general, c 440

Roman times and lost on the way to Italy.

The overall artistic direction of the adornment of Athens Pericles put into the hands of his friend the sculptor Phidias, who had established a great reputation by the middle of the century. Many of his works are recorded, but only Roman copies survive and the identification is not always certain. The so-called Lemnian Athena of bronze stood on the Acropolis. It was regarded as the sculptor's most beautiful work, and to some seemed even to excel the Cnidian Aphrodite of Praxiteles (p. 132). It has been recognized in marble copies: the body in Dresden, the head (OPPOSITE) in Bologna. The goddess stood looking at a helmet held in her right hand, while her left hand held a lance resting on the ground. In this lively head we can see clearly the features which ancient critics admired, 'the outline of the face, the delicate cheeks, the finely proportioned nose'. The date is c 440, the dedicators Athenian colonists of the island of Lemnos in the north Aegean.

Again we can compare a surviving original in bronze, originally gilt. A head of Nike (Victory) from the Athenian Agora, the ancient civic centre, slight work though it is, shows something of the same hard, linear precision in its modelling (NEAR RIGHT). The date is perhaps decade later than Phidias' Lemnian Athena, and the echo of it may even be deliberate.

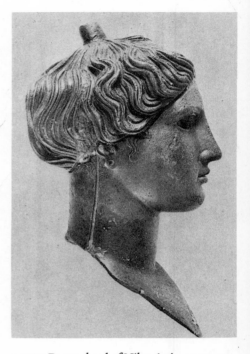

ABOVE Bronze head of Nike, Attic, c 440

RIGHT 'Lemnian Athena', after an original by Phidias, 450–440

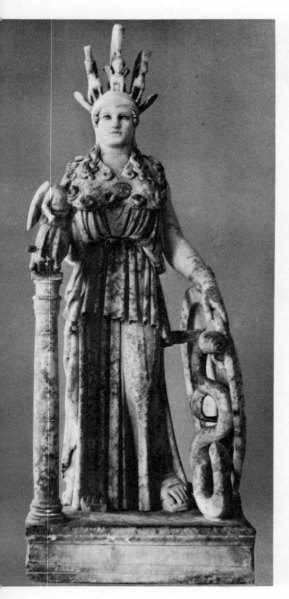

We may look at the composition of the Athena Parthenos, even though it is poorly represented in the copies (LEFT). The original, forty feet high, of ivory and gold and made in the years *c* 447–439, stood in the Parthenon. The goddess stands fully armed: on her head a helmet with triple crest of a sphinx between winged horses; about her shoulders the formidable *aigis*. On the goddess's right hand a winged figure of Victory alights, while her left hand rests on the rim of her shield, within which coils the sacred snake. Originally, it seems from representations on coins, the left hand also held a vertical lance. It is an awesome figure, made more solemn by the heavy folds of the drapery; and the only movement is provided by the drawing back of the left foot. On the shield Phidias depicted the war of Greeks and Amazons (cf. illus. pp. 122–3, 142–3), and included there 'a figure of himself as a bald old man lifting up a stone in both hands, and a very fine portrait of Pericles fighting with an Amazon'. The self-portrait is recalled in the copy (RIGHT). To some, this seemed sacrilege, and contributed to the eventual success of legal proceedings taken against Phidias by the enemies of Pericles and the building programme.

Phidias fled to Olympia and there completed his most famous work: of ivory and gold, the Olympian Zeus was one of the Seven Wonders of the ancient world. We get little idea of it

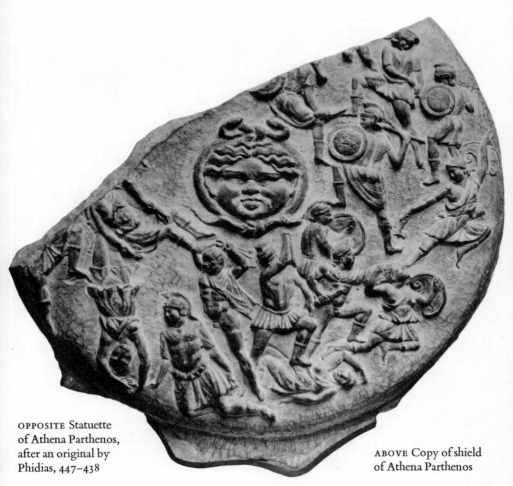

OPPOSITE Statuette
of Athena Parthenos,
after an original by
Phidias, 447–438

ABOVE Copy of shield
of Athena Parthenos

from later representations, but
fortunately the traveller Pausanias has
left a full description. Colossal and
seated, it seemed to the Roman professor
Quintilian 'to have added something to
traditional religion'. It is said that on the
day when the Zeus was first unveiled to
the public Phidias concealed himself
behind the door to hear what people
would say about it. Then, when the
temple closed for the night, Phidias
climbed a ladder to make such
modifications to the face as their

comments had suggested. Apocryphal
or not, this story illustrates an important
feature of the theory of art current in the
fifth and fourth centuries: the untrained
majority knew better than the artist.
Here, if anywhere, is the interaction of
the sculptor's ideal with common
observation which gave Greek art its
direction.

The greatest monument to Phidias'
oversight of the Athenian building
programme is of course the Parthenon
which, however, probably bears the

West front of
the Parthenon,
447–432, showing
position of the
sculptures

mark of no single stroke of his chisel.
This Doric temple of Athena was built
on the Acropolis between 447 and 432,
and its design reflects the quest for
novelty which notoriously marked the
Athenian character from the writings of
the contemporary historian Thucydides
to the time of St Paul. The central
building or *cella* was surrounded by
a single colonnade on the long sides, with
a double row of columns at front and
rear; but the canonical proportions of

six columns by thirteen were varied to
give a broader colonnade of eight by
seventeen. The Parthenon carried more
sculptured decoration than any other
Greek temple. It is of three kinds,
metopes, frieze, pediments (see view of
the west end, ABOVE). Ninety-two
metopes, carved between 446 and 440,
decorated the outside of the building,
alternating with triglyphs above the
architrave. This is the canonical place for
metopes, though the decoration of so

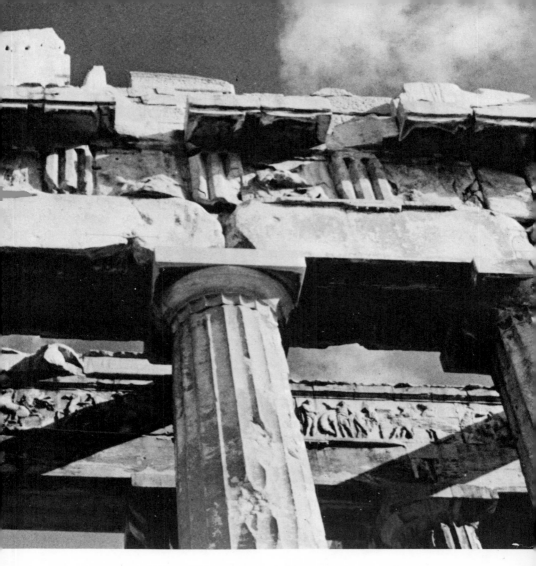

many with relief sculpture of high quality is unparalleled. The frieze, however, was an experiment. Normally a continuous frieze is the Ionic architect's equivalent of the Doric triglyphs and metopes, set above the architrave externally. Here it surrounded the top of the outer wall of the *cella*, for most of its 510 feet (155 m) visible only at an awkward angle from within the colonnade. The pedimental sculptures occupied the gable ends of the temple, and were the last work to be done, probably in the years 438–432. The major part of the sculpture is in London, the remainder largely in Athens and Paris.

The metopes bore various subjects: at the two ends of the temple, the battle between gods and giants and the battle between Greeks and Amazons; on the south and north sides, the battle between Lapiths and Centaurs (p. 78), and various scenes from the legend of Troy. The

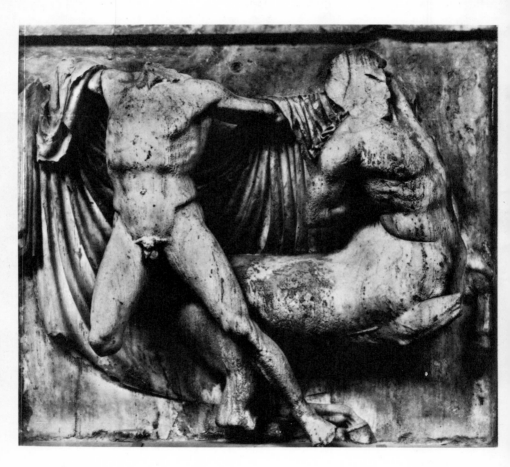

triumph of reason and order over chaos, and the triumph of Hellenism over barbarism, symbolized by these legends, were the laurels upon which the Athens of Pericles now rested. The metopes shown here all came from the south side and represent scenes of single combat between Centaurs and Lapiths (nos. 27,

28, 30, 31). No. 27 has a victorious Lapith (ABOVE). The Centaur, wounded in the back, seeks to escape. But the Lapith seizes the back of his head to strike a second blow. The contrast of the taut body of the Lapith against the idly hanging folds of his cloak makes an exceedingly dramatic composition. On

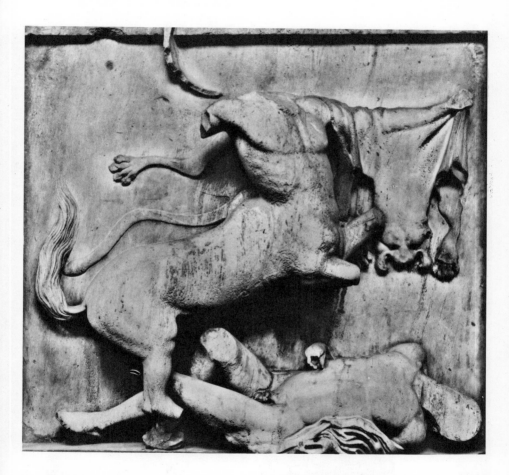

LEFT AND ABOVE
Battle of Lapiths and Centaurs,
south metopes of the Parthenon

no. 28 (ABOVE) the Centaur is the victor.
His enemy lies at his feet, relaxed in
death: notice the lolling head, and the
position of the right hand and left arm.
The exultant Centaur triumphs over him,
holding the lion's skin which is his shield.
The violent speed of the action is
emphasized by the way in which the

lion's tail and leg stream out behind. On the Centaur's shoulder was a wine-jar, his weapon hastily seized from the feast. On no. 30 also the Lapith is defeated (BELOW). Forced to his knees, he tries to fend off the Centaur with his right hand and reaches with his left for a new missile. But the Centaur has him by the head, and will shortly deliver the final stroke. Again we may notice the sharper impression of the relief caused by the use of the cloak for background. See too the agony in the Lapith's face expressed by the mouth and furrowed brow. No. 31 shows an earlier stage (OPPOSITE); the Lapith is about to be

BELOW AND RIGHT
Battle of Lapiths and Centaurs, south metopes of the Parthenon

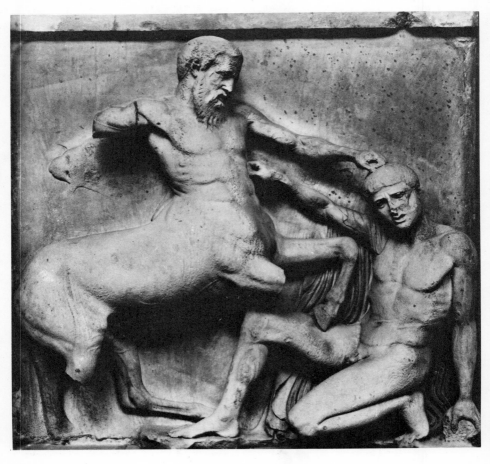

thrown by the Centaur who has him by the throat. Desperately he grasps the Centaur's ear, and the Centaur's face is contorted with the pain. This relief is clearly by a different artist or artists from the last: the treatment of the Centaur's hair is the clearest evidence.

Some idea of the self-reliance of Periclean Athens, its liberation from superstition, can be gained from the fact that the frieze of the Parthenon, though religious in content, represents a human scene from real life, not an heroic episode from mythical antiquity. We are shown the central procession of the city's chief festival, the Great Panathenaea, which

was celebrated with especial pomp once every four years. It is possible that a particular occasion is meant: the first celebration in the mists of legend and a celebration by the heroes who fell at Marathon in 490 are two suggestions among others. But the iconography of the human participants is unspecific – in contrast with the clear identification of the divine spectators by their commonest conventional attributes – and it is more likely that the scene is general.

The procession travelled from the city to the Acropolis to bring a newly woven sacred robe for the holiest antique image of Athena. At the centre of the east side,

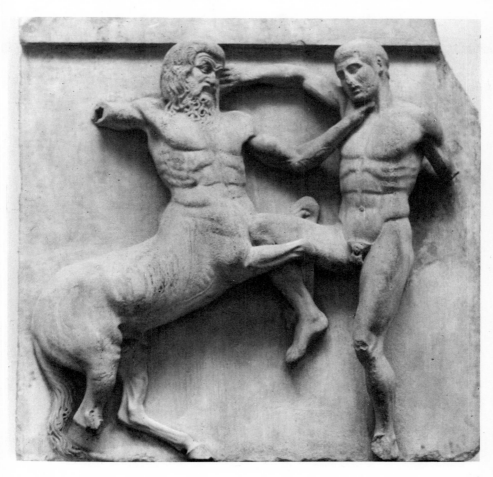

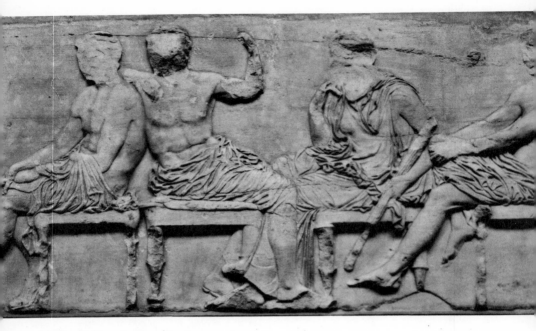

Gods watching the Panathenaic procession,
frieze of the Parthenon

the old robe is being folded away in the
invisible presence of the gods, who sit on
either hand with their backs to the scene.
To the left and facing left (ABOVE) are
Hermes, Dionysus, Demeter, and Ares,
with others not illustrated here; to the
right, Posidon, Apollo, Artemis, and a
very fragmentary Aphrodite (OPPOSITE).
The treatment of the drapery is
interesting: already it is losing its solid
forms and becoming more clinging, to
show the forms beneath. The heads are
particularly well done. On the other three
sides of the temple we see the participants
in the procession, starting at the south-
west corner and making their way along
both north and south sides to the eastern
end. On the west side the contingent of
horsemen mounts and prepares to mount
(OPPOSITE). One youth, wearing
a breastplate, is already mounted and
ready to set off on his spirited horse. He
controls it calmly and firmly: notice the

tense muscles of his arm. Behind him
another youth, naked but for a short open
cloak (*chlamys*), fastens a pair of greaves.
On the north side, the feverish horse-
men in full career, a look of intent
concentration on their faces as they
urge on their mounts (pp. 102–3). One
technical point is of great interest:
though the composition often entails five
or six superimposed planes, the total
depth of the relief is only a little more
than two inches (5 cm). Further along in
the procession we have a group of young
men in voluminous cloaks and carrying
jars of water on their shoulders (p. 102,
BELOW). At the right, another jar is being
raised from the ground, while at the
very edge we see part of a flute-player:
the procession marched to music. The
folds of the drapery are particularly fine,
and there is a strongly individual style in
the faces with their down-turned
mouths. Nor has the artist overlooked

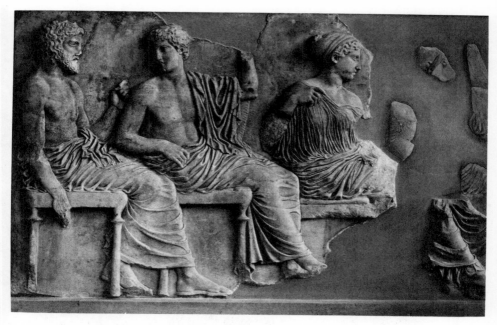

ABOVE Gods watching, and (BELOW) cavalry joining
the Panathenaic procession, frieze of the Parthenon

the opportunity to make of these water-carriers a formally repeating pattern. On the south side, the subjects run parallel with those on the north. Here, the sacrificial oxen are being led along, approaching the eastern end (p. 103, BELOW). They are not all equally happy at their fate: one tosses back its head while three young men discuss the best way of restraining it. The motion of

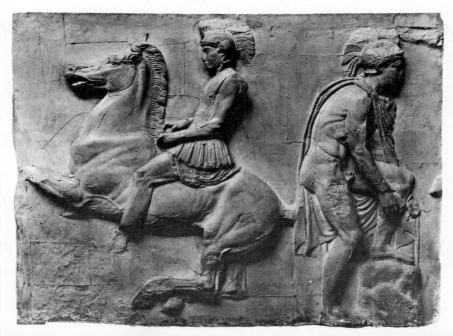

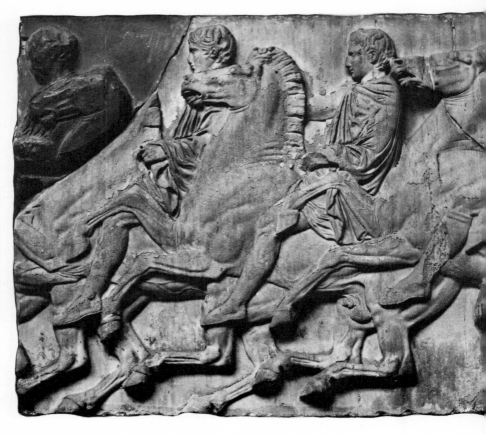

Panathenaic
procession, frieze
of the Parthenon:
ABOVE Cavalry
LEFT Waterbearers
RIGHT Cattle for
sacrifice

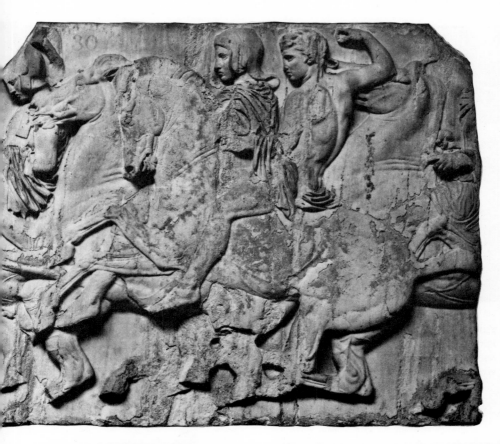

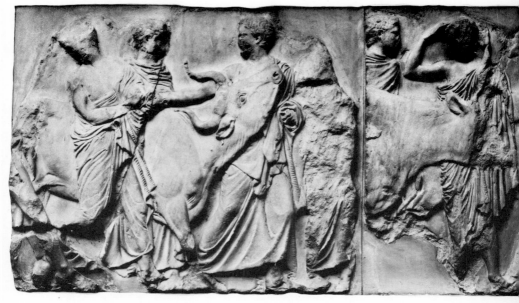

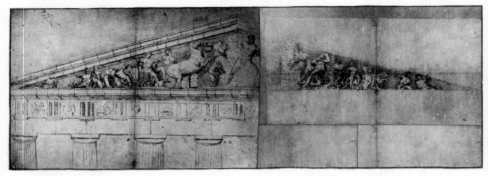

TOP Gods and goddesses at the birth of Athena:
Parthenon, east pediment, drawing, 1674
ABOVE Athena and Posidon compete for Attica:
west pediment, drawing, 1674

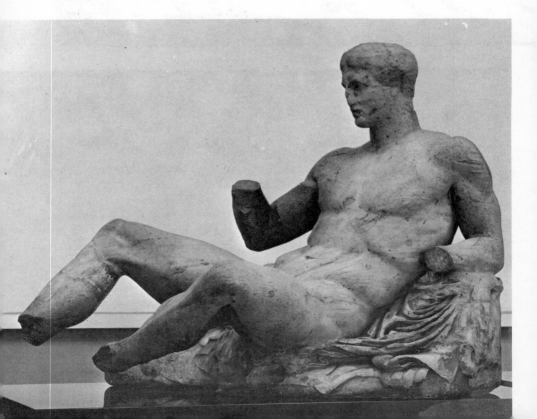

the figure behind this animal's head is particularly well observed, hurrying along yet turning his head full around to talk to his companion.

Lastly, the pediments. These were badly damaged in the late seventeenth century, when the Parthenon served as an arsenal for the Turkish garrison against the invading Venetians. Fortunately drawings survive which show both the east and the west pediments before this damage (OPPOSITE). Even so, the centre of the east pediment is missing, destroyed twelve centuries before, when the Parthenon became a Christian church with an apse at the east. The subject of the east pediment was the birth of the goddess Athena. According to legend, Hephaestus split the skull of Zeus with an axe, and from it Athena emerged fully armed. This part of the subject, now lost, seems to be reflected in a free copy on a Roman well-head in Madrid.

The whole scene was framed by the rising of the sun on the left, in his chariot – only the horses' heads and one arm of the charioteer are visible in the drawing – and on the right, the setting of the moon, shown by the head of one chariot-horse: the time is fixed at dawn. The other figures on the left are Dionysus or Heracles (OPPOSITE, BELOW), Persephone, Demeter, and perhaps Hebe the cup-bearer of Zeus (BELOW). The interest and excitement at the remarkable

OPPOSITE, BELOW Dionysus or Heracles: Parthenon east pediment
Demeter and Persephone learn of the birth of Athena: east pediment

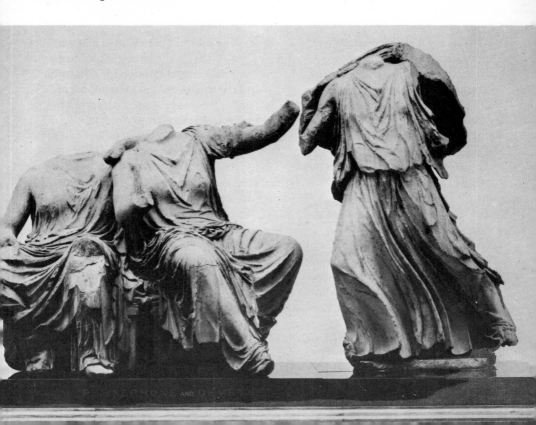

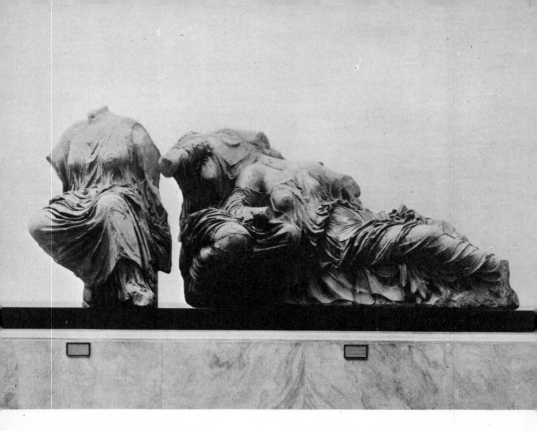

event taking place increases as we approach the centre: Hebe starts away in alarm, Demeter throws up an arm, Persephone begins to turn; but 'Dionysus' has not yet noticed anything. A similar device can be seen at the right of the gap (ABOVE): a group of three goddesses, not securely identified, the excitement already great as one spins round in her seat, while the other two are not yet much aroused. Two of the heads, now missing, can still be seen in the drawing. Of the moon's chariot, all is in Athens apart from one horse's head illustrated here. This head, in London, is a masterpiece of animal sculpture in the modelling of eye and nostril and mouth. The approach of the new style for drapery is clearly seen in the clinging and form-revealing robes of all the goddesses, with their knife-edge folds.

The subject of the west pediment (see p. 104) is the struggle of Athena and the sea-god Posidon for possession of the land of Athens. To support his claim, Posidon caused a salt spring to gush from the Acropolis rock, symbolizing the offer of power at sea. Athena in reply caused an olive tree to sprout – and was judged to have made the more useful gift and so to have won the contest. Olive oil and the sea were the traditional foundations of the Athenian economy. In the centre of the pediment the two gods are shown, each starting back from the other's magic. The remainder of the pediment was occupied by the gods' transport, their chariots, and by their supporters. In the left angle lies a truly magnificent male figure, a river-god of one of Athens' streams, Ilissus or Cephisus (OPPOSITE). The identification,

suggested by analogy with the east pediment at Olympia (cf. pp. 76–7), is supported by the wet and clinging drapery. The god is shown in the act of raising himself on his left arm and turning his head to obtain a better view of the contest. The anatomical contortions involved are shown with a complete mastery of essentials, and the figure is perhaps the most accomplished in either pediment.

Another fine group of pedimental sculpture of this period, c 440, was carried off from Greece by the Romans. It is impossible to make any confident conjecture as to the temple for which the figures were designed. The style, however, certainly points to the Peloponnese. The subject is the massacre

LEFT Three goddesses, and the head of one of the chariot-horses of the moon: east pediment of the Parthenon
BELOW River-god, west pediment

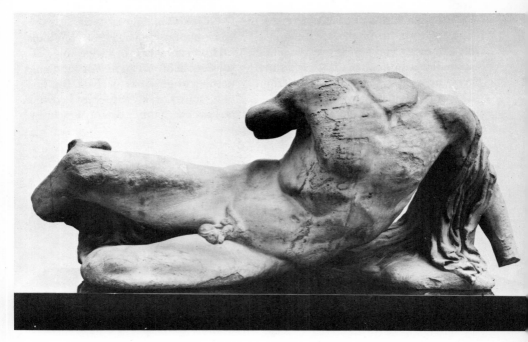

of the children of Niobe by Apollo and
Artemis. Niobe had boasted that she was
at least equal to Leto, their mother, on
account of the greater number of her fine
children, seven sons and seven daughters.
She was punished for her sacrilegious
boast by their death. The whole scene
probably showed Apollo and Artemis in
the centre (compare the two figures
sharing the centre of the west pediment
of the Parthenon) with dead and dying
Niobids in various attitudes at either side.
From the left corner, a dying son with
immature but athletic figure raises his
right hand to his wound (BELOW).
Notice the realistic sagging of the belly
and the genitals as he lies. We may
compare 'Ilissus' from the Parthenon
(illus. p. 107). On the same side a daughter
falls to her knees, shot in the back (RIGHT).
She clutches at the wound with her right
hand, and can no longer hold up the
heavy cloak which has impeded her

flight. Her mouth is slightly parted, the
agony shown with great restraint. The
clear lines and firm modelling of this
young woman are particularly skilled.
In the corresponding position on the
other side of the pediment, a younger
daughter runs away (FAR RIGHT). She
holds her garment up behind her head as
a shield, and has not yet been hit. Here too
is great purity of line. All three figures are
more thick-set, more squarely built, than
those of the Parthenon. It is this feature
which marks their Peloponnesian style,
the influence of the school of Polyclitus.
His influence may be seen too in the
Niobids' heads (cf. pp. 114–16).

Polyclitus of Argos was the
contemporary and chief rival of Phidias.
Of his many works in a wide range of
subjects, in bronze or in ivory and gold,
nothing original has survived. But two
of his most famous statues are known in
no fewer than thirty copies of each, and

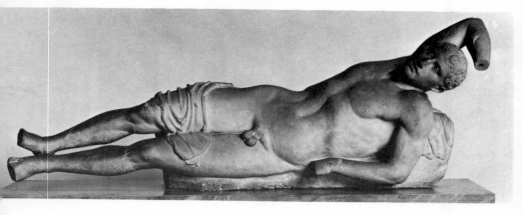

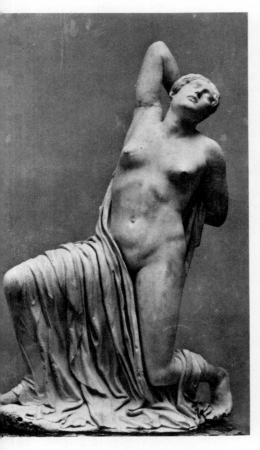

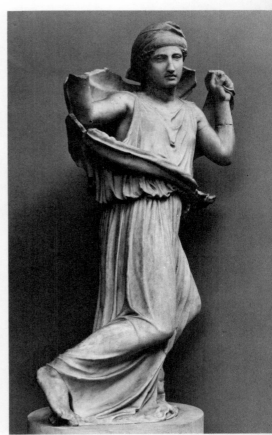

LEFT AND ABOVE
Children of Niobe, from a pediment,
Peloponnesian, *c* 440

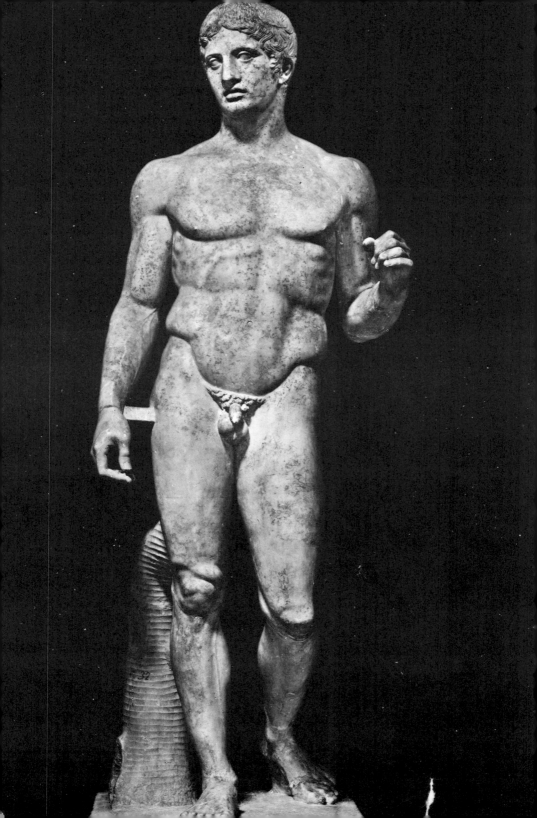

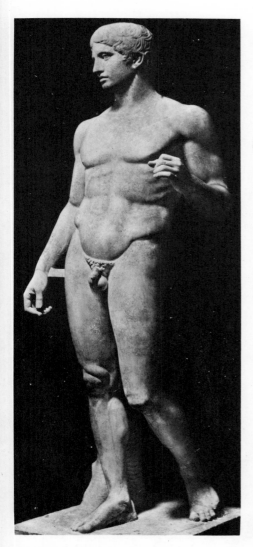

LEFT AND ABOVE
'Canon' (Doryphorus) after a bronze
original by Polyclitus, 450–440

that is sufficient testimony to his
reputation in the ancient world. To us
he is especially noteworthy for the
interest he took in the theory of art, for
he wrote a book entitled *The Canon* in
which he argued that beauty was a matter
of what the Greeks called *symmetria* – not
'symmetry' in our sense but an elaborate
system of 'comparative dimensions' or
(as we should say) proportion. He went
on to propose a particular system of
proportions as the embodiment of human
beauty. Polyclitus' *Canon* is the clearest
example of the tendency to conceptualize
and idealize which was the mainspring
of Greek art. The book itself has not
survived, apart from a few telling
quotations; but the sculptor illustrated
his theory by means of a statue, also
called 'Canon', and this has come down
to us in many copies, the most complete
in Naples (LEFT). It took the form of a
young man walking with a spear on his
shoulder – in the Greek word for the
subject, a *doryphorus*. It is evident that the
proportions canonized are those of the
rather stockier figure fashionable from
c 450 on: no longer the willowy gods and
men of the Transitional period. The
statue well illustrates other features too
which ancient critics noticed as marking
Polyclitus' style: the square build, the
way of stepping forward with one leg.
The anatomy is virtually perfect; and a
new device of harmonious and
rhythmical composition is the way in
which the relaxed arm is on the side of

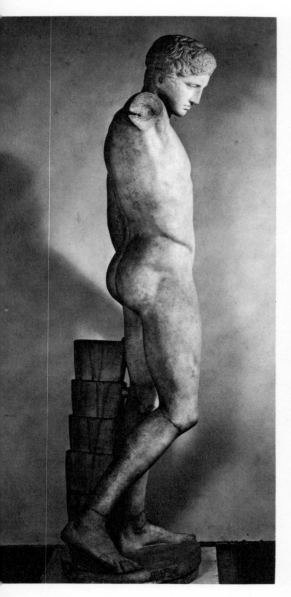

the tense leg, and vice versa, so giving an equal measure of activity to both sides. The critics also noticed that all his works were constructed on a single pattern, with a single pose. We may lean on that judgment to identify other recorded works of Polyclitus in Roman copies. One such is the so-called Westmacott athlete (LEFT) the position of whose feet agrees with the footmarks on the original signed base of Polyclitus' statue of the athlete Cyniscus at Olympia, celebrating a victory in the games of 456. This, then, would be an early work; and certainly more than a trace of the slender forms of the previous generation can be detected in the otherwise Polyclitan composition. Again the whole weight is placed on one foot, and the modelling of the body is very similar. Notice also the treatment of the hair, in short curled locks clinging closely to the shape of the skull. The athlete is placing a wreath of victory on his head with his right hand. If Cyniscus preceded the 'Canon', the Diadumenus (RIGHT) represents a later stage, perhaps *c* 420. Here is a younger athlete, with less prominent muscles, tying a victor's ribbon about his more luxuriant hair: it is almost a trademark of Polyclitus that the hair radiates from a 'starfish' of locks at the crown. In this late work there is, of course, greater variety in the pose; but the effect is unmistakably similar, and illustrates the freedom which the sculptor could find within the rules of his *Canon*.

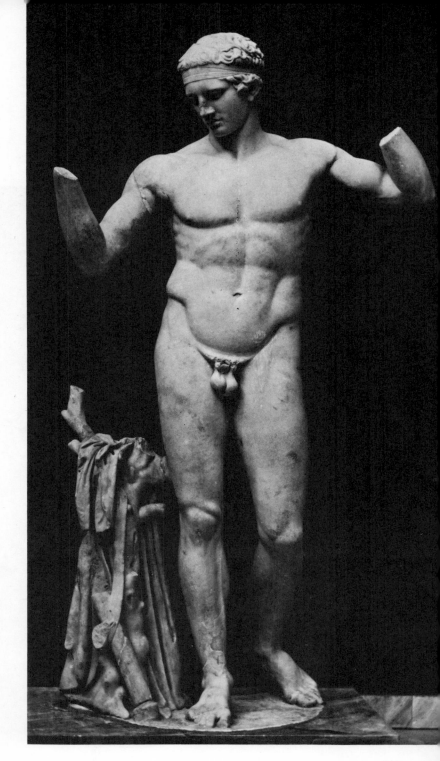

OPPOSITE
'Westmacott
athlete',
after a bronze
original by
Polyclitus,
c 450

RIGHT
Diadumenus,
after a bronze
original by
Polyclitus,
440–430

The rivalry of Polyclitus and Phidias came to a head in a formal competition for Amazons at Ephesus. Among five contestants. Polyclitus was placed first, Phidias second, Cresilas (see pp. 87–89) third. Of the three types popular with later copyists, the proportions and stance of Polyclitus' figures can be recognized in one, downcast with pain at her wound, who leans upon her spear (NEAR RIGHT: cf. the stance of the Westmacott figure, p. 112), the grace and subtlety of Phidias in one who uses her spear apparently to vault upon her horse (CENTRE). The third, superficially Polyclitan but not quite sufficiently so in stance, leans upon a pillar; she will be Cresilas'. Accept the ancient verdict or not: the comparison certainly clarifies the difference between the Athenian master and the great Argive, whose influence quickly spread all over Greece (cf. also frontispiece).

In 431 Athens embarked on war against Sparta and her allies. After twenty-seven years she lost it, and with it the empire that had been the source of so much wealth. During the last third of the fifth century the lion's share of state revenue had to be devoted to the war. Yet Athens still found resources, if on a much reduced scale, for public buildings and works of art. It was during

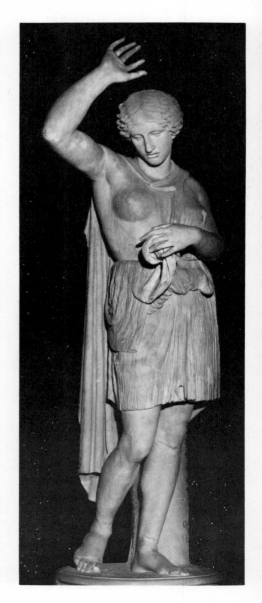

Amazons, after bronze
originals at Ephesus,
attributed to (LEFT TO RIGHT)
Polyclitus, Phidias and Cresilas

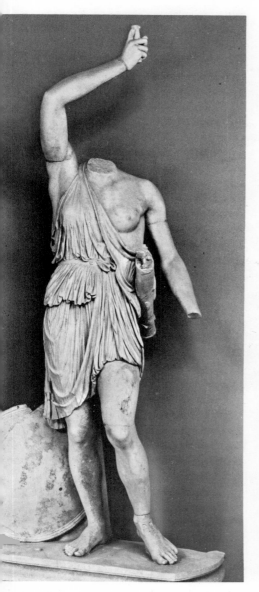 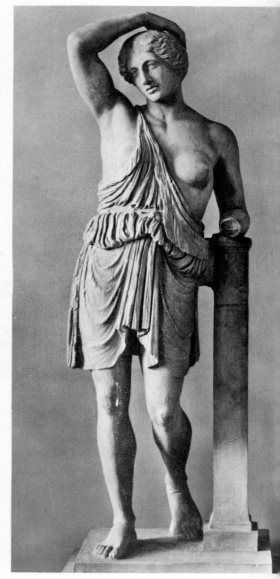

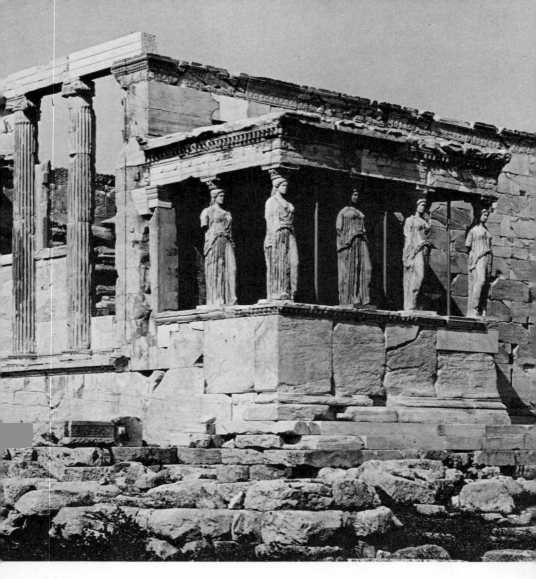

the first decade of the war that the city began a joint temple of Athena and the legendary king Erechtheus, on the Acropolis. This Erechtheum, as it is called, had a small porch on one side, the roof supported by Caryatids, statues of women (ABOVE AND OPPOSITE, LEFT). They give an excellent idea of the way in which a sculptor of this violent period could yet convey an impression of complete repose. The drapery is thin,

ABOVE Caryatid porch of the Erechtheum, 425–415
RIGHT one of the Caryatids
FAR RIGHT Procne and Itys, by Alcamenes, c 420

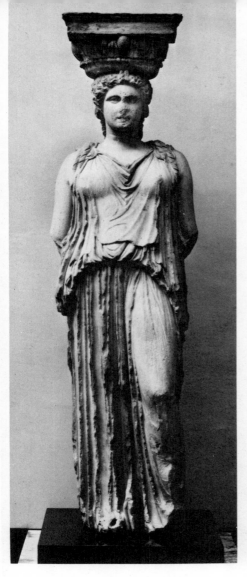
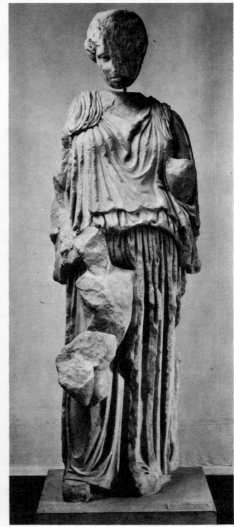

where it touches the body. But there is no wind to blow it, and the resulting folds recall the fluted column for which the figures did duty.

A closely similar treatment of drapery is to be seen in a statue from the Acropolis of a woman with a young boy pressed against her skirt (ABOVE, RIGHT). It seems to be a group seen by Pausanias, of the Athenian princess Procne with her child Itys, whom she killed in a futile act of revenge against her husband for his rape of her sister. If so, it is the work of Alcamenes, one of Phidias' leading pupils – and he no doubt will have designed the sculpture of the Erechtheum also.

An exaggeratedly filmy, clinging style of wind-blown drapery came into vogue in the last quarter of the fifth century, a new ideal. Gone are the heavy woollen expanses of the Olympia

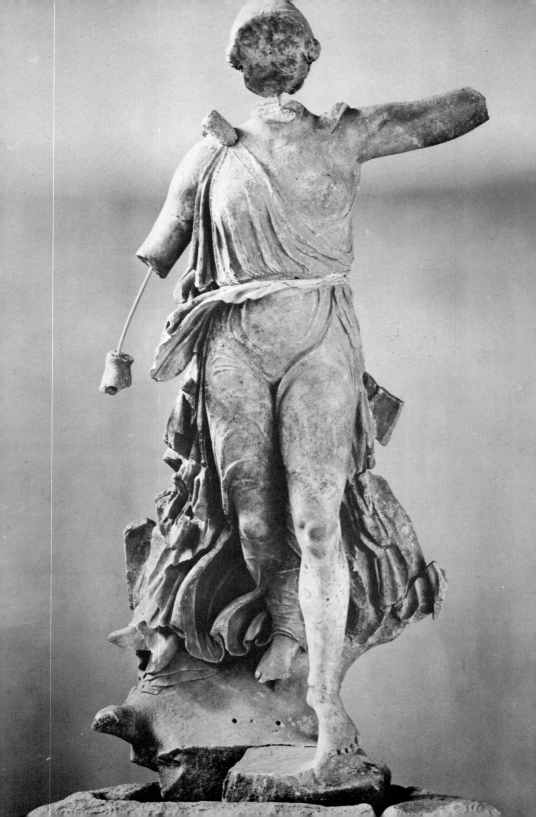

metopes: here is sheerest silk. One of the earliest surviving statues in the new style is the figure of Victory by Paeonius of Mende in northern Greece (Thrace), set up by the people of Messenia and Naupactus to celebrate the defeat of Sparta by themselves and their Athenian allies at Pylus in 425 (LEFT). The goddess swoops down from heaven, borne on the back of an eagle, to land on a high triangular base. The left shoulder and left leg are undraped; but the drapery is so thin and the wind blows it so strongly that the forms of the right shoulder and leg are equally visible. The whole effect must have been dramatic indeed when the flowing drapery at the back was undamaged. The same subject, treated in much the same style, provided an *akroterion* for the Stoa of Zeus in the Agora at Athens (RIGHT: and cf. p. 124).

Victories are popular in wartime. In 421 the Athenians built a small temple on the very edge of the Acropolis in honour of Athena as Victory personified. A few years later, *c* 410–407, they added a parapet to protect visitors from falling. It was left plain on the inside, the outside carved in relief but visible only at a distance. The design was perhaps by Callimachus, a sculptor famous for his extreme delicacy of detail; but half a dozen hands can be detected in the execution. We look at two panels. The first is the work of two different artists, discernible in the different treatment of the drapery of the two winged Victories,

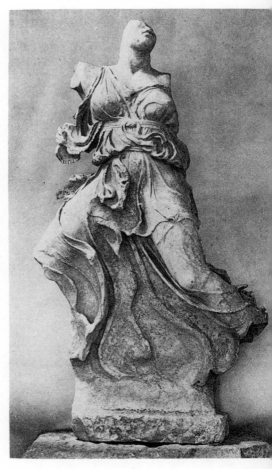

ABOVE, *Akroterion* from Stoa of Zeus, Athens, 420–410

OPPOSITE Nike (Victory) by Paeonius of Mende, 425–420

119

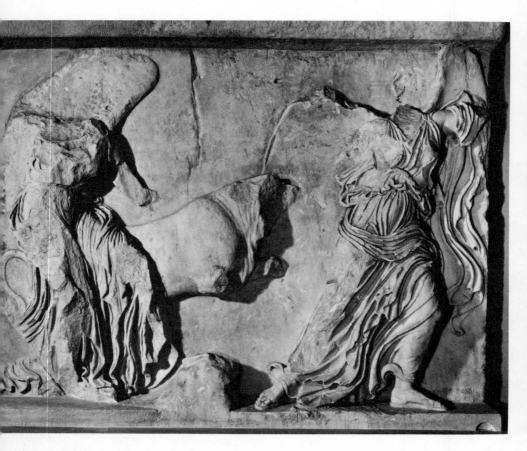

who bring an unwilling ox to the
sacrifice, the one pulling it back by a
rope, the other perhaps with a hand on
its horn (ABOVE). On the second panel,
by the best of the artists employed, a
winged Victory stoops to remove her
sandal, and in the process her garment
slips from her right shoulder (OPPOSITE).
All three figures give an interesting view

Frieze on parapet surrounding
temple of Nike, Athens, c 410:
ABOVE Figures of Victory with bull
for sacrifice
RIGHT Victory untying her sandal

FAR RIGHT Nereid (sea-nymph) from
tomb monument at Xanthus, c 400

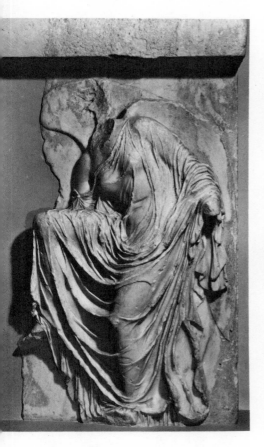

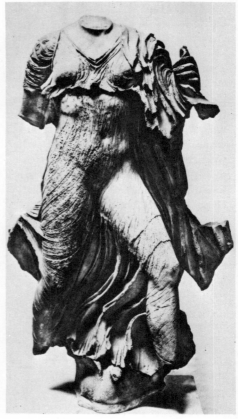

of the possibilities of drapery within the late fifth-century conventions.

Athenian artists of this generation both worked abroad and deeply influenced local artists elsewhere in the Greek world. Closely related to the Nike parapet is a tomb at Xanthus in Lycia, the so-called Nereid monument. It took the form of a temple on a high base surrounded by sculptured friezes (see the Mausoleum, p. 142). The pediments carried sculpture, and more figures stood on the corners of the roof. Between the columns stood the Nereids, daughters of the Old Man of the Sea, some of them with gulls beneath their feet (ABOVE). The drapery here clings not only because of the wind but through salty dampness too.

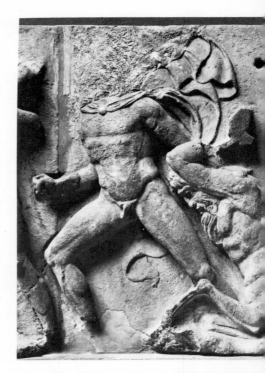

At about the same time, the outwardly
Doric temple of Apollo at Phigalia
(Bassae) in the centre of the Peloponnese
received an internal sculptured frieze.
There are two subjects, the battle of
Greeks and Amazons and the battle of
Lapiths and Centaurs. We may look at a
representative slab of each (ABOVE AND
BELOW). Everywhere the wildly flying
drapery emphasizes the confusion of the
scene, though the faces are almost
totally expressionless. The architect was
Ictinus, who designed the Parthenon.
Hence it is not surprising that the
design of the frieze owes much to
Athenian art. In particular the Amazon
frieze is almost monotonous in its
repetition of the poses of the Athenian
Tyrannicides (cf. p. 58). But the
thick proportions of the figures
mark the workmanship as wholly
Peloponnesian.

Similar sculpture, fragmentary though
it is, comes from the temple of Asclepius
at Epidaurus, built in the first quarter of
the fourth century. The building
accounts of this temple, which have
survived on stone, tell us that Timotheus
carved the *akroteria* of one pediment –
that is, the free-standing figures which
surmounted and flanked the triangular
pediment itself – and also certain reliefs.
As the style of the surviving *akroteria* of
both pediments is uniform, any of the
figures may be those carved by
Timotheus, with clinging drapery which
recalls the Nereid monument and

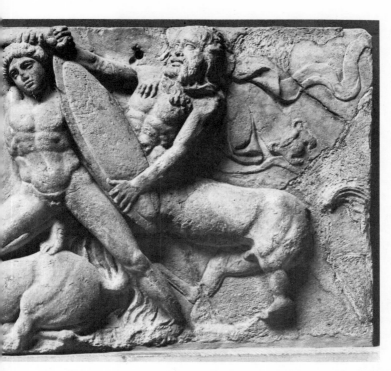

Frieze inside
temple of
Apollo, Phigalia
(Bassae), c 420:
LEFT Lapiths
and Centaurs
BELOW Greeks
and Amazons

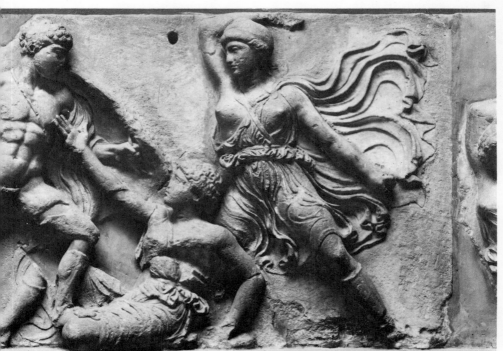

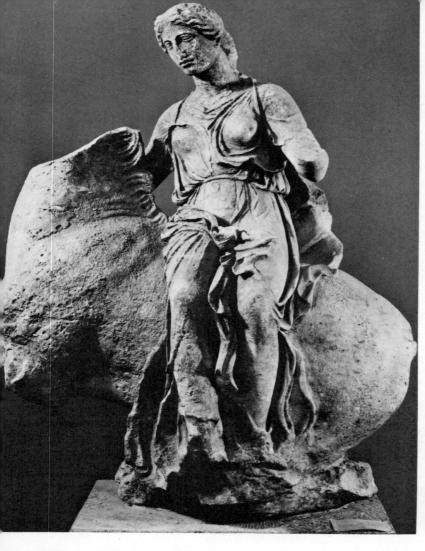

exaggeratedly linear facial features
designed to be seen at a height. The
figures were of Nereids and Victories
(ABOVE). Presumably the architect
provided clay models, and the main
features of the style are his: hence the
uniformity of the two sets.

We end this period by looking at two
Athenian gravestones. The first, of
Hegeso the wife or daughter of Proxenus,
may be dated *c* 400 (OPPOSITE). From a
casket proffered by her maid she takes a
necklace, originally shown in paint.

Within the architectural framework, the
composition is held together by long
flowing lines, notably the left arm of
Hegeso leading to the right arm of the
girl, and the imaginary line formed by
the maid's line of gaze leading to
Hegeso's right hand, at which she herself
is staring also.

Secondly, the tomb of the young
cavalry officer Dexileos, killed (as the
inscription tells) fighting the
Corinthians in 394, at the age of twenty.
He is seen in the act of killing a fallen

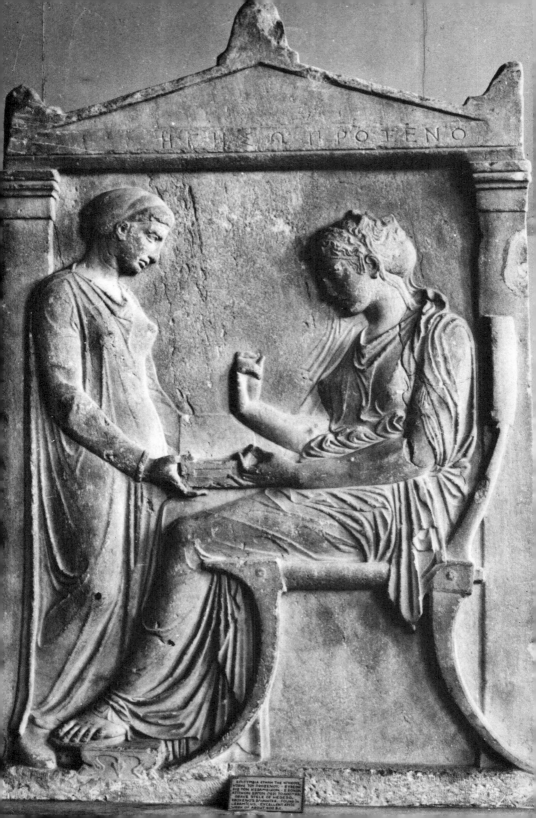

HΓHΣIΠPOΞENO

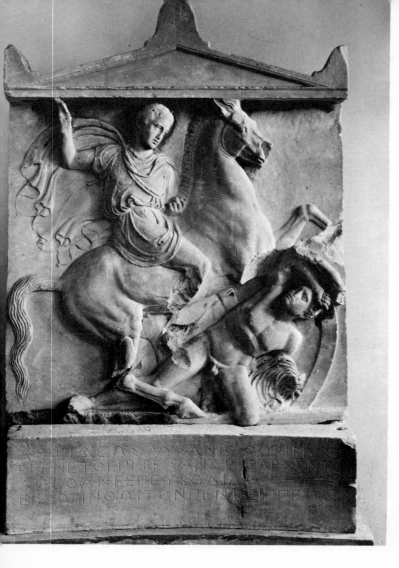

Gravestone
of Dextileos,
Attic, 394

enemy with his spear which, like the reins
and other details, was added in bronze
(ABOVE). The absence of credible
everyday armour lifts the scene from the
human and particular to the heroic and
general: the contest is idealized. The thin
and billowing drapery is once again
characteristic of the period. The effort
of the fallen Corinthian to defend himself
gives rise to a most successful attempt to
depict his writhing motion. This scene of
violence is reminiscent of the Phigalia

frieze and looks forward to the
Mausoleum.

The quality of Dexileos' tombstone
serves to warn us that the military and
political collapse of imperial Athens in
404 at the end of the long war against the
Peloponnesian states is marked by no
such artistic watershed as signalled the
end of archaic Greece in the war with
Persia. Nevertheless there is a change of
temper in the fourth century, to which
we now turn.

6 Fourth-century Naturalism
c 380 - 300

The sculptors of the fourth century ceased to see men as gods; on the contrary, their gods were as men. In the fifth century Phidias' brother, the painter Panaenus, once asked him what pattern he had had in mind when he began work on his statue of Zeus at Olympia. 'I thought of those lines of Homer', he replied: ' "The son of Cronus spoke, and nodded his dark brow, and the divine locks waved on his immortal head; he made great Olympus quake." ' The gods of the fourth century are too human to be forbidding. Indeed, the most famous of divine statues of this period, Praxiteles' Aphrodite at Cnidus, is said to have been inspired by a living model. Yet stil these gods have enough abstraction and dealism to make them acceptable as more than one man's notion of divinity.

The period begins with two Athenian sculptors, equally close in blood and in style, Cephisodotus and his more famous son or younger brother Praxiteles. Of Cephisodotus' work we gain some precious information from ancient literature. In his guide book Pausanias tells us of a statue made for the Athenians and set up on the Areopagus – Mars Hill of St Paul – 'an image of Peace bearing the child Plenty in her arms'. The allegorical nature of the subject suits the philosophic temper of the time, the age of Plato. The Athenians valued the statue enough to depict it on their coins, and hence a number of Roman copies have been recognized, the best preserved in Munich (NEXT PAGE). The cult of Peace (Eirene) was introduced into Athens in 375, and the statue will have been erected soon afterwards. Peace stands, supporting herself on a spear. The child on her arm originally held a cornucopia in his left hand. The most characteristically fourth-century feature is the tender inclination of the mother's head towards her child, answered by the child's own upturned face and the playful gesture of his right arm. At first sight the drapery seems to have the solidity of the mid-fifth century (cf. pp. 72–3). But it is infinitely more complex – a resolidification, after the tempestuous transparency of the Nike balustrade or the Nereid monument (pp. 120–1), or even the contrast of extreme transparency side by side with opaqueness to be seen in the Erechtheum Caryatids (cf. illus. p. 117).

The pose of Cephisodotus' statue, reversed, is reproduced in an original bronze Athena found at Piraeus in 1959, and previously known through a copy, the so-called Mattei Athena in the Louvre (p. 129, RIGHT). The treatment of the drapery is similar also, and the Athena may well be by Cephisodotus, who is known to have worked in bronze. The attribution is not certain, however, for there is an equally close comparison to be made with a fragmentary statue from the Agora, very probably to be identified as the Apollo

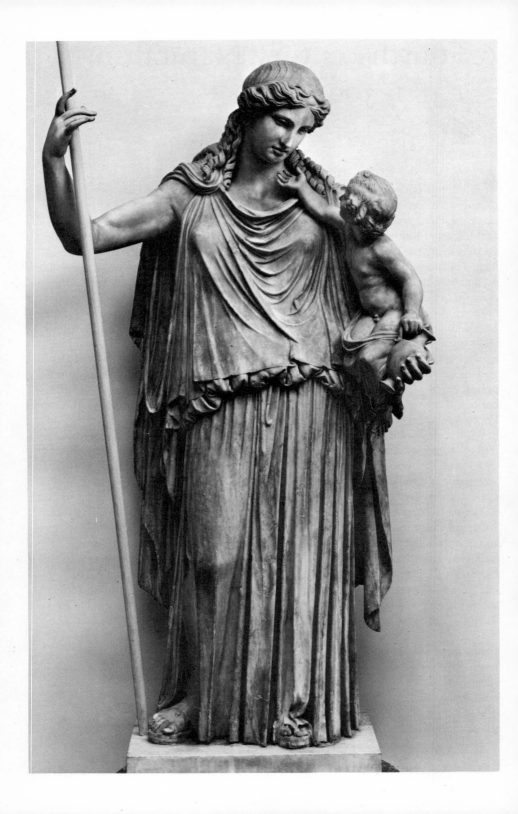

Patrous of Euphranor, who also worked as a painter and wrote on proportion and colour (BELOW, LEFT). Small-featured, with long hair escaping under her crested helmet, Athena stands in relaxed pose, one leg trailing, one arm extended. Her aegis is worn almost casually, over one shoulder. This Athena is of a gently unwarlike nature which was to become popular in later times: she goes well with her sister Peace.

We turn to Cephisodotus' younger relative Praxiteles. His career covers a long period: Pliny sets him in the year 364, and he signed a statue base at

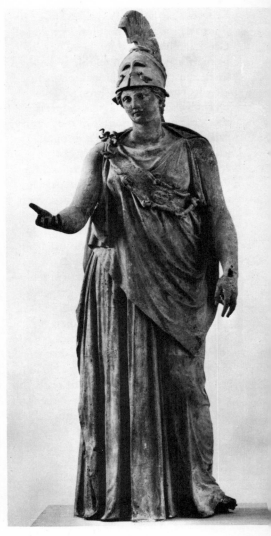

OPPOSITE Eirene and Plutus, after a bronze original by Cephisodotus, 375–370

LEFT Apollo Patrous by Euphranor, c 370
ABOVE Bronze Athena attributed to Euphranor or Cephisodotus, c 370

129

Leuctra c 330. After Polyclitus and Phidias, he was the most influential of all Greek sculptors. Unlike them, he was primarily a worker in marble and indeed made the material fashionable again, after its long eclipse by bronze. The Hermes and Dionysus at Olympia is a work of about the middle of the century: whether original or copy is disputed (OPPOSITE). It was evidently not regarded as Praxiteles' masterpiece, for Pausanias mentions it barely in passing, and other writers not at all. Moreover it was not much copied in the Roman period. The composition immediately recalls the Peace of Cephisodotus: again the adult turns tenderly towards the child, who stretches out an arm in reply – this time, towards a bunch of grapes which Hermes holds tantalizingly out of reach. Though the composition is similar, the feeling of the work is different. The strong S-shaped curve of Hermes' body imparts a greater vitality, but it is a relaxed vitality, made restful by the almost dreamy expression of the face, and the gentle variation of the modelling with no sudden contrasts. The tree-trunk and obtrusive strut have been regarded as additions of the Roman copyist, who imitates a bronze original in more brittle marble. But the limitations of the material are timeless, and any pose but the directly vertical always demands support. In fact Praxiteles regularly introduced such supports – witness Apollo Sauroctonus' tree-trunk (p. 135)

and Aphrodite's robe and water-pot (p. 132) – and the standard of workmanship is such as to put most Roman copyists to shame. Notice the extreme naturalism of the drapery with variations even within a single plane. The proportions are interesting: the head is small, the legs very long. So Praxiteles departed completely from the canon of proportions established by Polyclitus (p. 111), and preferred to turn towards the new system which Lysippus was to canonize a generation later (p. 148).

The best-known work of Praxiteles is his nude Aphrodite, carved in Parian marble about the middle of the fourth century. This, says Pliny, 'is the finest statue not only by Praxiteles but in the whole world'. Praxiteles made two statues of the goddess of love, the one draped, the other nude, and offered the people of Cos the choice of either figure at the same price. They chose the draped version as the more chaste and severe. The version they rejected was bought by their neighbours the Cnidians. More than two hundred years later, King Nicomedes of Bithynia tried to buy the statue, offering to pay off the Cnidian national debt, vast as that was. But they preferred to put up with any misery rather than sell the statue, for it was that which had put Cnidus on the map. The Roman copies – the most complete is in the Vatican (ill. p. 132) – have been identified from coins of Cnidus. The

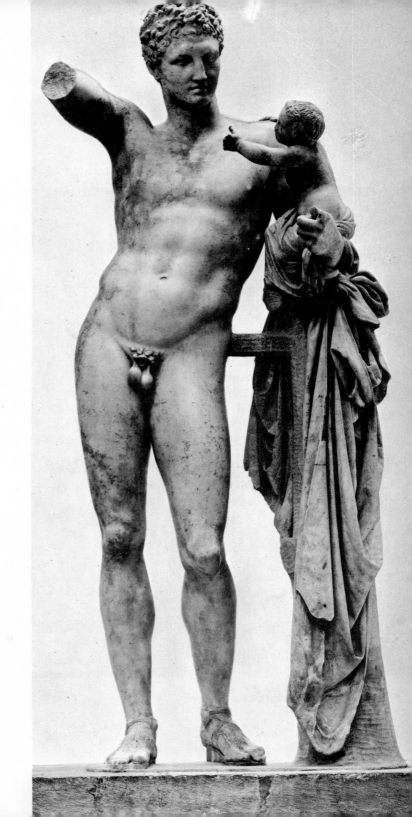

Hermes and the
infant Dionysus,
by Praxiteles, c 350

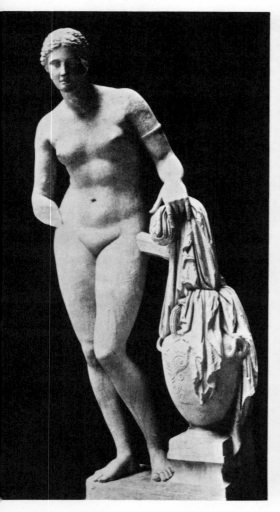
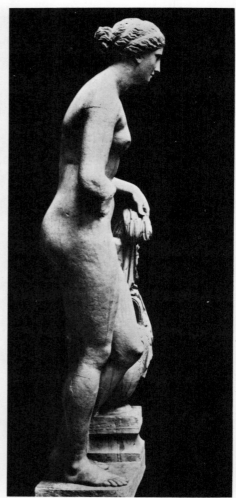

Aphrodite of Cnidus, after an original
by Praxiteles, c 340

goddess stood in a shrine open on all
sides, and was evidently designed to be
seen from every direction. The right arm
is brought down in front of the body, in
the traditional gesture of the *Venus
pudica*; the left hand allows the goddess's
bath-robe to fall over a ewer of hot
water, the folds making a splendid
contrast with the smooth surface of the
body. Aphrodite is about to take a bath,
indoors. As with Hermes, the head is
small, the legs long. Ancient opinion
especially praised 'the hair and forehead
and delicately pencilled eyebrows . . . the
melting look in the eyes, with their bright
and joyful expression', and also the
'disdainful smile' which the Roman
copyist has totally failed to capture. Pliny
believed that the goddess herself assisted
Praxiteles in his task; more worldly
opinion held that the model was his
mistress Phryne.

The Aphrodite of Arles, in the Louvre
(RIGHT), is another work of which the
original may be attributed to Praxiteles
on grounds of style. There is no certain
literary reference to the work – unless it
be the draped Aphrodite whom the
Coans chose. The stance recalls the
Hermes: left arm bent, head inclined
towards the left hand, right arm raised.
But the weight is set on the left leg, not
on the right. The proportions of body
and face are Praxitelean. But we may
hope that the original showed a more
beautiful face than the Roman copyist
could reproduce.

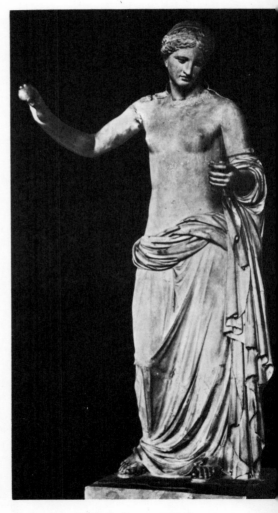

'Aphrodite of Arles', after an original
attributed to Praxiteles, *c* 340

133

Three original heads of the period give some idea of what we have lost. The first, at Petworth, may even be by Praxiteles himself (RIGHT). The mouth and chin, eyes and eyebrows, are carved with extreme delicacy. Again, as in the Hermes and the Cnidian Aphrodite, the head is turned away from the direction of the torso. The subject is Aphrodite – or Phryne. The second head, in Boston (BELOW, LEFT), belongs to the next generation. (The misty look is due to over-enthusiastic cleaning with acid). The face has a sad look: certainly not Aphrodite. It may have come from a funerary statue, and traces of drapery remain. Clearly it is in the Praxitelean tradition. So too is a particularly fine head in Athens which belonged to a statue standing in the precinct of Athena Alea at Tegea (BELOW, RIGHT).

We look at one more copy of a work of Praxiteles, Apollo Sauroctonus

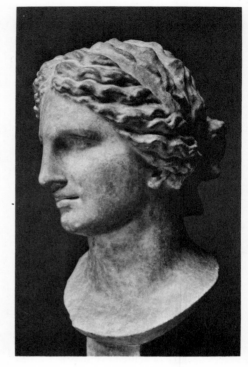

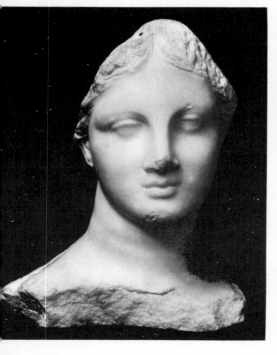

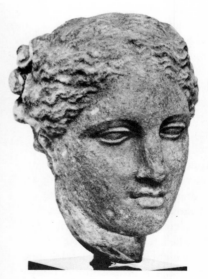

TOP Head of Aphrodite, attributed to Praxiteles, c 350
BELOW, LEFT Head from Chios, c 350
ABOVE Head from Tegea, c 350

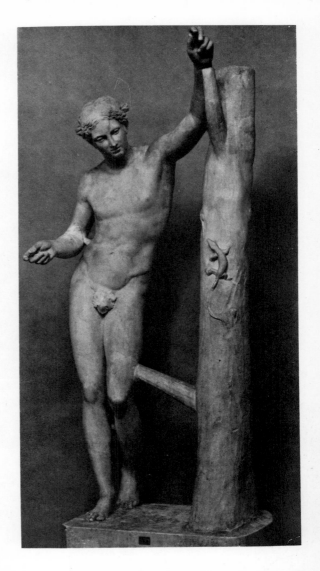

Apollo killing the lizard, after
an original by Praxiteles, *c* 340

('Lizard-slayer': ABOVE). The date is
close to those of the Hermes and of the
Cnidian Aphrodite. Again we see the
pronounced S-curve of the body, the
gracefully languid pose. The god, if we
can really believe him divine, stands
watching a lizard creeping up a tree. In a
moment he will kill it with the arrow
held horizontally in his right hand. The
original seems to have been of bronze,
though most of Praxiteles' commissions
were carried out in marble. Indeed, the
use made of the supporting tree-trunk
betrays the mind of one accustomed to
thinking in terms of the technical
limitations of stone.

Many other works of Praxiteles are
recorded, some of them plausibly
identified in Roman copies, and one or
two fragments recognized as originals.
At Mantinea he made a group of Leto
and her children Apollo and Artemis, to

135

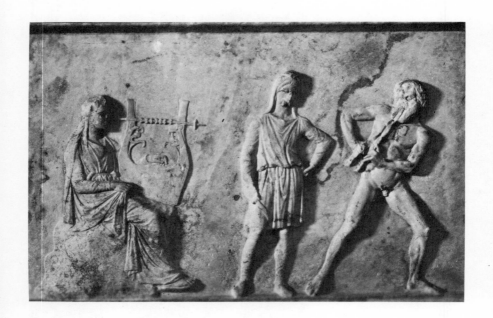

stand on a base carved with reliefs of
Apollo and the satyr Marsyas and the
nine Muses (ABOVE AND RIGHT).
The workmanship of this base is too
perfunctory to be by the author of the
Hermes; but the design must have been
by Praxiteles himself, and the pose of the
figures has much in common with his
other work and even recalls
Cephisodotus.

Praxiteles' influence was immense: the
Aphrodite of Cnidus began a whole
tradition which lasted for centuries.
He was imitated by many of his
contemporaries. The 'Praxitelean curve',
for instance, can be seen clearly in an
original bronze of c 350–325 found in the

Base for a statue by Praxiteles,
from Mantinea, c 350:
ABOVE Front, the contest of Apollo
and Marsyas
RIGHT Sides, three Muses on
each face

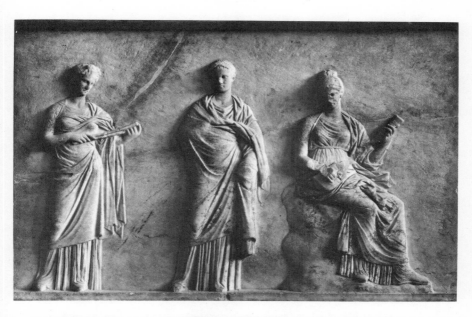

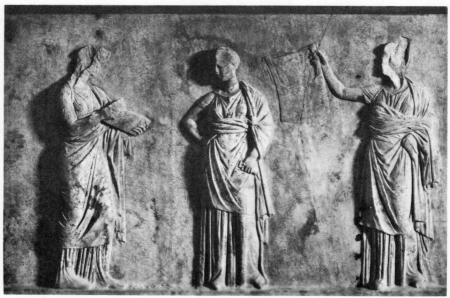

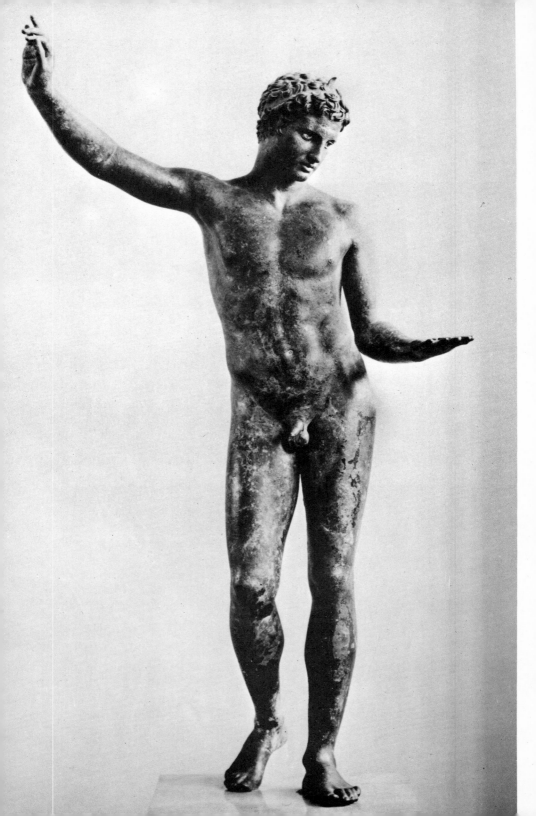

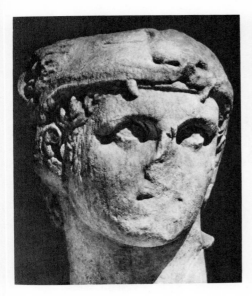

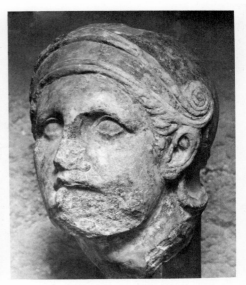

LEFT Bronze boy,
found off Marathon,
340–300

ABOVE Heads of Heracles (LEFT) and a
warrior from pedimental sculpture of the
temple of Athena Alea at Tegea, c 370–350

sea off Marathon (OPPOSITE). The pose is
a variation of the Hermes: the position of
head and arms is identical, that of the
body very similar except that the weight
is on the left foot. The legs are long; but
the head is not reduced to Praxitelean
proportions, and the hair and rather
broad face are of course quite unlike
Praxiteles' work.

Among Praxiteles' contemporaries and
rivals was a Parian, Scopas. But whereas
Praxiteles concentrated on free-standing
statues, Scopas was best known for
architectural sculpture. His name is
associated with three buildings in
particular. The first is the temple of
Athena Alea at Tegea, built in the second
quarter of the fourth century. Here he
served as architect and also provided two
statues to stand inside the temple.
Pausanias describes the pediments at
length, but does not specify the sculptor.
The work involved in carving them was
of course far more than one man could

attempt; and even if Scopas did design
the pediments, the most that can be said
of the surviving fragments is that they are
from his workshop. Among the best are a
number of battered male heads, notable
for their non-Praxitelean squareness, with
sunken eyes and fleshy upper eyelids
(ABOVE). The second building on which
Scopas was engaged was the new temple
of Artemis at Ephesus, begun in 356 to
replace the archaic temple, destroyed by
fire on the night of Alexander the Great's
birth. The structure, one of the seven
wonders of the ancient world, rested on
a forest of one hundred and twenty-seven
columns 'each donated by a king and
sixty feet in height'. Thirty-six of these
columns had bases decorated with
sculpture (a feature repeated from the
earlier temple), and one of them is said to
have been the work of Scopas. The
chances of his authorship of one of the
three which survive in anything but
fragments are slim indeed. On the finest

139

of them we certainly seem to find the same square faces and deep-set eyes, though not hooded (BELOW). Hermes, messenger of the gods – recognizable by his staff or *caduceus* – is leading Alcestis towards winged Death, visible at the left: she had offered herself to die in place of her husband Admetus, King of Thessaly, but was later rescued by Heracles and restored to the land of the living. The other figures surrounding the drum included Admetus himself, and Hades and Persephone, the King and Queen of the Underworld. Persephone can be seen at the right, her stance and drapery recalling the Peace of Cephisodotus (p. 128). Scopas' third great architectural commission was at the Mausoleum, to which we shall return.

The tradition of the Attic grave-relief continued through the fourth century. One of the best, found in Athens at the River Ilissus, is to be dated soon after 350 (BELOW). Originally it was surrounded by a pedimented architectural frame. The nude young man is the dead, cut off from all communication with his father, who gazes at him in grief, while his slave or younger brother sits weeping on a step, and his dog noses the ground with a puzzled air. The stylistic influence is that of Scopas: the broad square head and the deep-set eyes remind us of Tegea. The young man of the grave-relief could well have served as model for the youth found in the sea off Anticythera (OPPOSITE). Of bronze, rather more than life-size, the statue represents an athlete who has just thrown a ball. Again we see the tradition of Scopas in the face, with its intense expression. The eyes are inlaid in coloured paste, and the eyelashes were cut out of thin sheet bronze and inserted separately (cf. the Delphic charioteer, p. 60). Notice the firm muscling of the

ABOVE Base of column of temple of Artemis at Ephesus, 350–330
RIGHT Gravestone from the Ilissus, Athens, c 340
OPPOSITE Bronze athlete, found off Antikythera, c 340

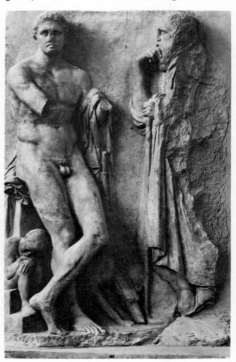

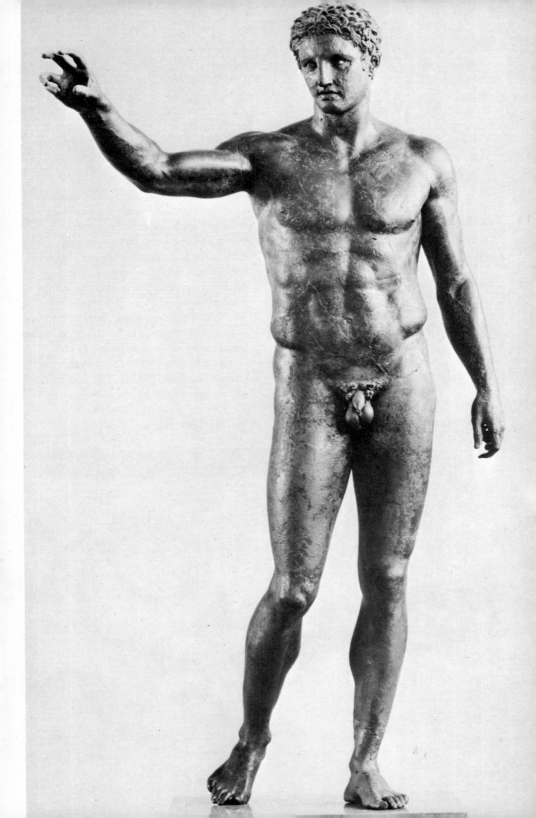

body and its rather square shoulders, as well as the stance. Unlike Praxiteles, the sculptors of Scopas' school seem to have been the heirs of the Polyclitan tradition.

The Mausoleum at Halicarnassus, another of the seven wonders of the world, was the tomb of Mausolus, Prince of non-Greek Caria in south-west Asia Minor and local viceroy of the Persian emperor. He died in 353. The tomb was commissioned by his widow Artemisia, but she died before it was completed. An elaborate structure in the tradition of the Nereid monument (see p. 121), its almost square colonnade stood on a high base enriched with free-standing sculpture on ledges and crowned by two friezes. Above the colonnade, lions paraded on the eaves. In place of a conventional pitched roof with pediments the whole was surmounted by a tall pyramid on which stood a four-horse chariot, apparently empty. The total height of the building is said to have been 150 feet.

The architect and sculptor of the chariot was one Pythius. The decoration of the rest of the tomb was by Scopas,

Battle of Greeks and Amazons, frieze from the Mausoleum at Halicarnassus, *c* 350

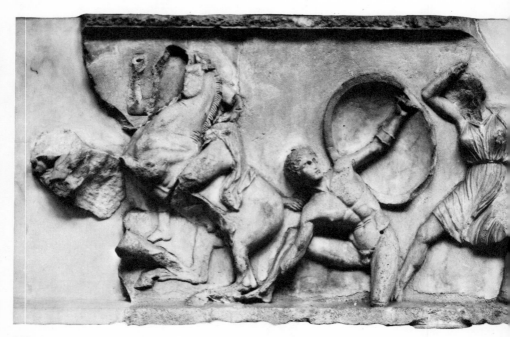

Timotheus (employed at the temple of Asclepius at Epidaurus, see p. 124), Leochares and Bryaxis. According to Pliny, each sculptor attended to one of the four sides. But the pieces which survive were not found *in situ*, though three contiguous slabs of the frieze were found together on the east side, reused in a much later construction. If they came originally from this side, which is quite uncertain, they would be, by Pliny's account, the work of Scopas. There is in fact no general agreement on the attribution; and the actual carving of the whole building must in any case have been more than four men could manage on their own. We look at two of the three slabs (BELOW). Their subject, the battle of Greeks and Amazons, occupied all four sides of the structure. The interaction of the figures in this lively scene is portrayed with harmony as well as boldness. Particularly notable are the violently twisted poses, especially of the Amazon who has her back towards us and of the kneeling Greek whose right thigh is sharply foreshortened to show its slant from front to back of the com-

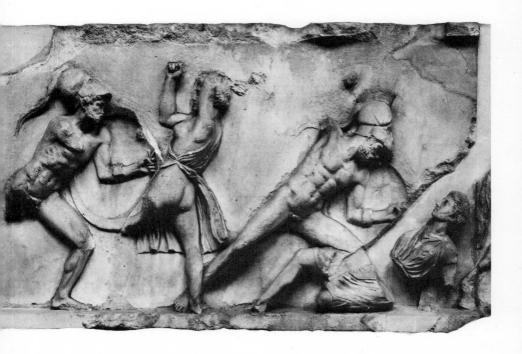

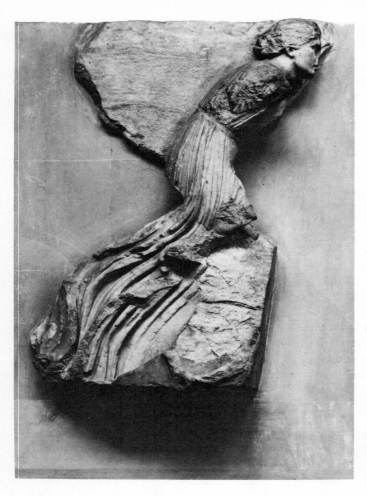

LEFT Charioteer,
from a frieze of
the Mausoleum

RIGHT Figures of
Carian rulers
('Mausolus' and
'Artemisia')

position. The contrast of flesh against
drapery is effective.

A third frieze, of chariots, surrounded
the *cella* in a repeating pattern
remarkable for the urgency of crouching
form and flowing drapery (ABOVE; it is
uncertain whether the upper and lower
parts belong together).

The friezes, however distinguished,
were but incidental to the main
sculpture in the round, which stood on
the ledges of the podium and – again as
on the Nereid monument – between
the delicate Ionic columns. Among them
were two which are conventionally iden-
tified as Mausolus and Artemisia them-
selves. (OPPOSITE). The identification
has no particular basis. But it is harmless
enough so long as it is understood that
they are merely the best preserved of a
series of statues which stood all about the
building, no doubt all of them members
of the dynasty. We do not know the
sculptor. Though the stance and the dress
are Greek, Mausolus' face is not:
hellenized, but still essentially Carian.
The drapery is unusual in that it shows
laundry creases as well as folds; otherwise
it has the complex solidity of the period.
The hair calls for comment, Mausolus

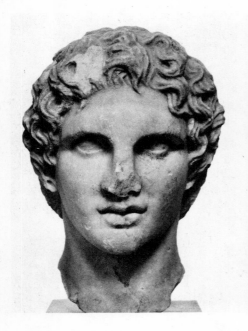
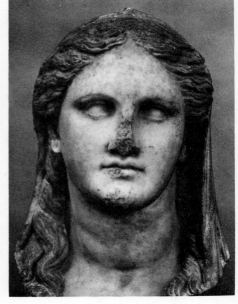

with lank locks hanging down behind him in a very un-Greek fashion, Artemisia with rows of small 'snail' curls above her forehead recalling a much earlier age in Greece.

A little way south of Halicarnassus, the city of Cnidus was a famous centre of the arts. There stood Praxiteles' Aphrodite (pp. 130–3); and from the same site comes a seated Demeter of *c* 350 or a little later which evidently belongs to the circle of the sculptors of the Mausoleum, yet shows some affinity with Praxiteles (RIGHT). The heavy drapery with its sweeping lines of creases and folds echoes the statues of Mausolus and Artemisia.

The goddess' head shows an almost Praxitelean grace and serenity, and the hair at once recalls that artist's Aphrodite. But the mouth is larger, and the overall effect quite different. Astonishingly similar to this Demeter, and undoubtedly a work of the same artist, is what appears to be a portrait head of Alexander the Great, from a statue on the Acropolis at Athens (LEFT). Alexander allowed few sculptors to portray him. From the short-list the name of the Athenian Leochares stands out, the only one of Alexander's portraitists also to have had connexions with the Mausoleum, of which he designed one side. Portraiture is of course

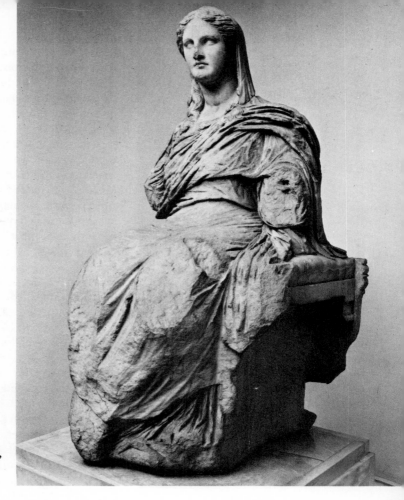

FAR LEFT
Alexander the Great,
attributed to
Leochares, *c* 330

LEFT AND RIGHT
Demeter from Cnidus,
attributed to
Leochares, *c* 330

the branch of the sculptor's art in which
the tension between ideal and real comes
closest to breaking-point. Leochares has
achieved the apparently impossible; for
it is not easy to explain rationally how
this head can be so like Demeter's
imagined countenance, and yet be
recognizably individual and a portrait.

In the second half of the fourth century
the central position of artistic excellence
passed from Athens to Sicyon in the
Peloponnese, a moderately prosperous
city of the second rank. The leader here
was Lysippus, Alexander's favourite
portraitist, who enjoyed a long career
extending from *c* 370 to *c* 320, and

founded a flourishing school. So
extraordinarily prolific was Lysippus that
he was credited with the production of no
fewer than fifteen hundred separate
works. No doubt the total is exaggerated.
But Lysippus worked mainly in bronze,
unlike Praxiteles and the Athenian
masters of the period who preferred
marble, and the greater speed with which
the necessary clay models could be
executed will account for some of the
increased output; technical assistants
could produce the bronze casts. We have
seen how Praxiteles tacitly ignored the
Polyclitan canon of porportions.
Lysippus, who had once declared that

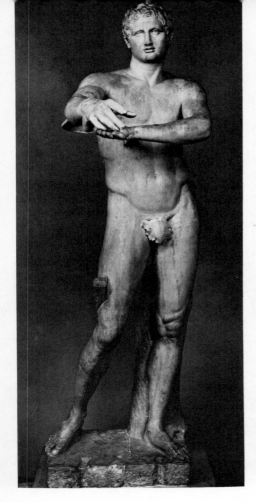

time of the prime empiricist Aristotle. Lysippus' innovations, briefly, were to decrease the size of the head and to make the bodies more slender and well-knit, so giving the appearance of greater tallness to his figures. He was also credited with a closer attention to a high standard of finish for minor details. This latter characteristic did not survive in copies of his work – to judge from the Apoxyomenus ('youth scraping himself') in the Vatican, a Roman copy almost certainly to be identified with Lysippus' work of this title (LEFT). The subject is an athlete removing the olive oil which served the ancients for soap and liniment simultaneously. The date is *c* 325–300. An original bronze of the period, recently retrieved from the Adriatic, comes at least from the school of Lysippus and may even be a work of the master (RIGHT). It is of a victorious athlete, who combines the facial softness and new proportions of the Apoxyomenus with a rather heavier treatment of the muscles. In a very similar pose but heavier yet and of squarer build, with an echo of Polyclitus, is a statue of the Thessalian Agias at Delphi (FAR RIGHT). It is probably a workshop version of a bronze which Lysippus modelled for dedication in Thessaly soon after the middle of the century. Of the original, only the signed base remains; and there is no means of telling how closely the marble version reproduced it. But the style is consistent with Lysippus' early admiration of Polyclitus.

Polyclitus' 'Canon' was his master, now openly proclaimed a new system; and he too illustrated it with a statue, entitled *Kairos* or 'Due Measure', which stood in his home town. According to Pliny, he criticized his predecessors for having represented men as they are: he, on the contrary, represented them as they appeared to the eye. Nature, he declared, not the work of other artists, was a fit subject for imitation. Here is the other side of that tension between the ideal and the empirical to which Greek art owed its creativity – and it is significant that the empirical case is first made explicit in the

Lysippus enjoyed many portrait commissions from Alexander, who considered that no other sculptor so well portrayed his courage in visible form. We have already looked at Leochares' ideal Alexander (see p. 146). Lysippus' empirical approach brought success, as

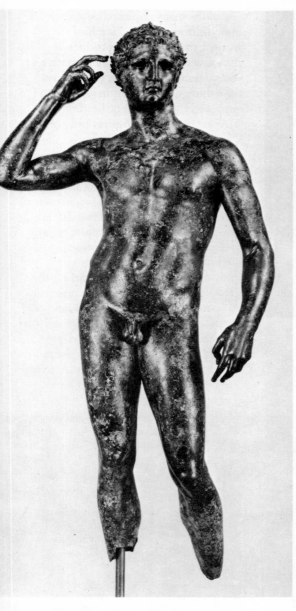

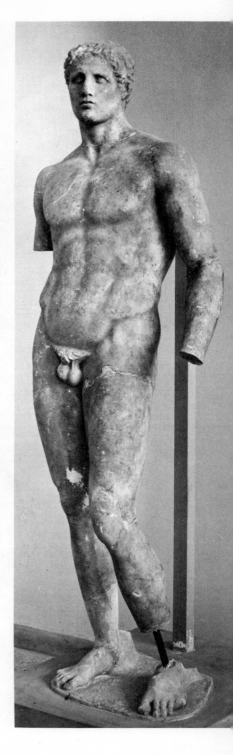

ABOVE Bronze athlete, attributed to
to Lysippus, *c* 325
RIGHT Agias, original of 344–334,
perhaps after Lysippus

OPPOSITE Apoxymenus, after an original
by Lysippus, 325–300

ABOVE Alexander the Great, after an
original attributed to Lysippus, *c* 330
OPPOSITE AND BELOW Alexander hunting,
sarcophagus from Sidon, 325–300

one of the many copies of his Alexander
may illustrate (LEFT). Like his
rivals, Lysippus could reproduce
Alexander's way of putting his neck on
one side; unlike them, he could show
something of the determination
expressed by that leonine head.

Apart from single figures and portraits,
Lysippus produced large groups
representing scenes of desperate action –
battles, hunts, chariot-races – in which he
showed excellent likenesses of the
participants. None of these has, of course,
survived. But a vivid impression of his
genius for this type of composition is
given by the so-called Alexander
sarcophagus. Used at Sidon in
Phoenicia at the end of the century, this
great coffin carries on one side reliefs of
Alexander fighting the Persians, and on
the other the king hunting a stag and
attacked by a lion (BELOW AND RIGHT).

With the death of Lysippus, wrote an
ancient critic, 'art ceased'. It is easy to see

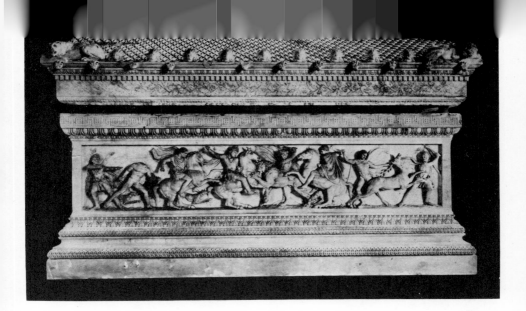

what he meant, for by that time nearly everything the Greeks attempted in anatomy, drapery, movement had been achieved, and the tension between real and ideal had found equilibrium. Yet in another sense Lysippus stands at a new beginning. His success in portraiture and also in free-standing groups of figures in violent action points the way forward from fourth-century classicism to the baroque exuberance of the Hellenistic period.

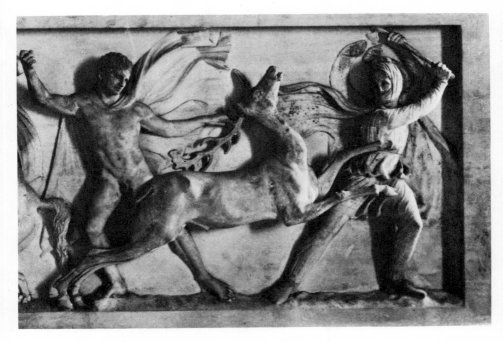

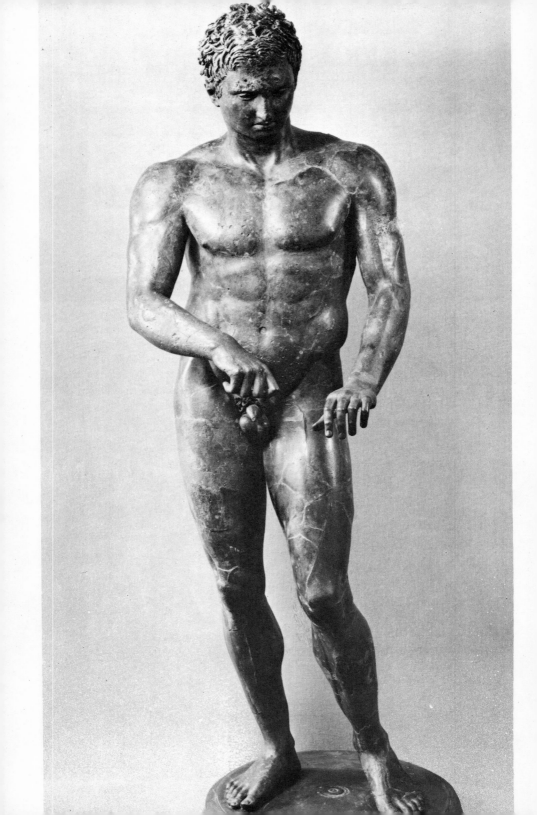

7 Hellenistic Virtuosity
c 300-150

In Greek history the Hellenistic period
begins with the death of Alexander the
Great in 323 and the wars of his generals
and successors, anxious to secure their
own share of the empire he left. In this
period, Greek culture was diffused over
vast territories of non-Greek peoples in
the Mediterranean and Middle East
generally, and the hellenizing process
which these nations underwent gives the
period its title. In art, the new and
flamboyant spirit of the Hellenistic
monarchs began to be felt by about 300,
and the restraint of Lysippus did not last;
although his emphasis on increased
naturalism was the major influence in
what followed. From his school, c 300,
come two fine original bronzes, an
athlete cleaning his strigil, from Ephesus
and long known (OPPOSITE), and the
fragment of a veiled goddess found
recently in the sea off Cnidus (RIGHT).
Their facial features proclaim them the
work of a single artist, and the naturalistic
influence of Lysippus is manifest in the
athlete's tousled hair.

Surviving Hellenistic works are so
numerous, and their range of themes so
diverse, that a fully coherent account of
the period would require a book to
itself. The vastly increased output
included a great mass of sculpture in the
classical tradition, derivative and
unexciting. Of greater interest is the
development of portraiture, the elaborate
realism of genre subjects, newly popular,
and a dramatic intensity of narrative art

OPPOSITE Athlete scraping himself,
bronze, from Ephesus, c 300

ABOVE Goddess, found off Cnidus,
bronze, c 300

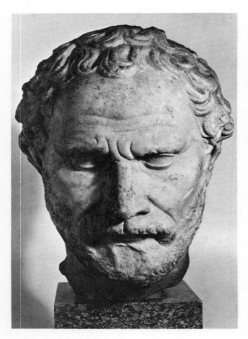

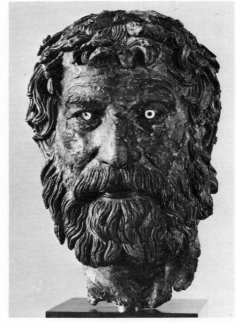

in the Pergamene school which rivals the triumphs of the baroque. We can do no more than show a small selection – with a necessary word of caution about chronology. It is much harder to date works of art stylistically in the Hellenistic period. On the one hand, so many different styles were followed at a single time – calm at Alexandria, violent at Pergamum, classical and traditional on the Greek mainland – and, on the other hand, there is no clearly traceable development from generation to generation.

Some of the grandest achievements of Hellenistic art were in portraiture, in which the balance shifted decisively in the direction of realism. Polyeuctus' figure of Demosthenes was unveiled in 280–79, more than forty years after the great Athenian orator's death. Several copies survive, the most complete in Copenhagen. The best copy of the head is in Oxford (ABOVE, LEFT). The simple device of the slanting lines between the eyebrows gives an extraordinary pathos to the frowning face. Rather later, *c* 250–200, is the portrait of an unknown 'philosopher' (ABOVE). This is a fine compromise between representation of the features of an individual, in the

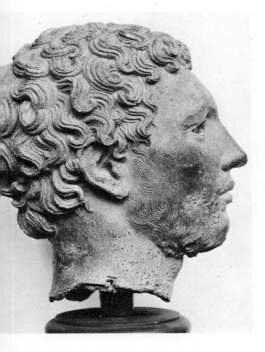

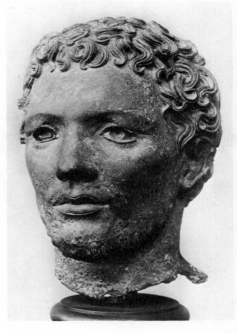

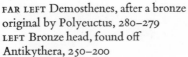
FAR LEFT Demosthenes, after a bronze
original by Polyeuctus, 280–279
LEFT Bronze head, found off
Antikythera, 250–200

ABOVE AND RIGHT Head of a Berber,
bronze, from Cyrene, c 250

eyes and nose and lower lip, and the
standard Hellenistic ideal of the thinker.
The naturalism of the unkempt hair is
particularly noticeable and successful.
Later still, probably, is the bronze head of
a Berber, from Cyrene (ABOVE).
Clearly a portrait, its non-Greek subject
is finely modelled: the bone-structure is
completely understood, but the
understanding is unobtrusive. The detail
of eyebrows, 'crows' feet', moustache
and beard, is equally convincing. The
very classical treatment of the hair is
similar to that on a seated statue of a
boxer, made c 150 (NEXT PAGE). The

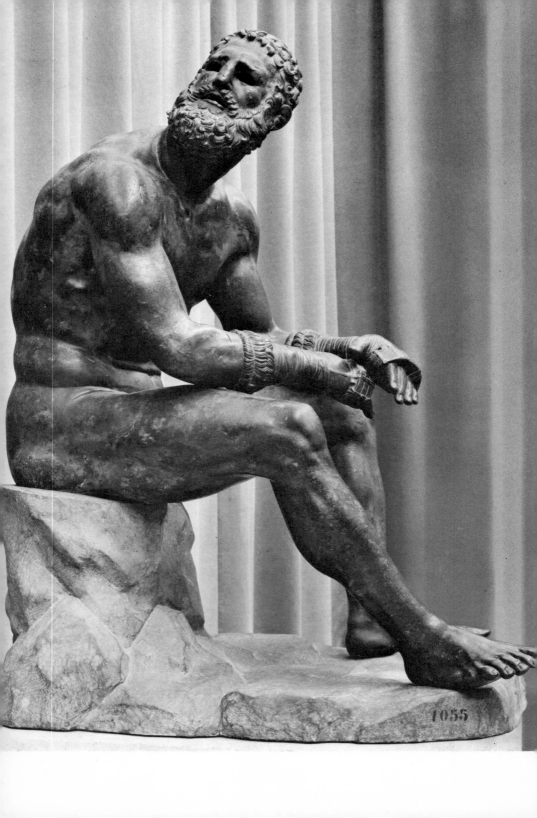

boxer is resting between rounds, none too pleased at the advice being given him by someone who stands at his right. His pose is relaxed, except for the hands which are held awkwardly because of their clumsy binding for the fight. There are gruesome touches of realism – the cauliflower ear, the flattened nose which makes it necessary to breathe through the mouth, from which the front teeth have been knocked out. Other details, including drops of blood oozing from newly torn ears, are not visible in the photograph. The statue is signed by the artist, Apollonius the Athenian. Lastly of the portraits, we may look at another complete statue, of similar date (RIGHT). Clearly a ruler, shown in heroic nudity, the subject is possibly Demetrius I Soter ('Saviour') king of Syria from 162 to 150. The pose, and the small size of the head in proportion to the body, recall the work of Lysippus; and it may well be that one of Lysippus' portrait-statues of Alexander was the ultimate model. But the look of apprehension as the king perhaps watches a battle can have had no model in Alexander.

The increased realism of portraiture is related to the love of genre subjects, scenes from everyday life treated realistically. A drunken old woman seated awkwardly on the ground,

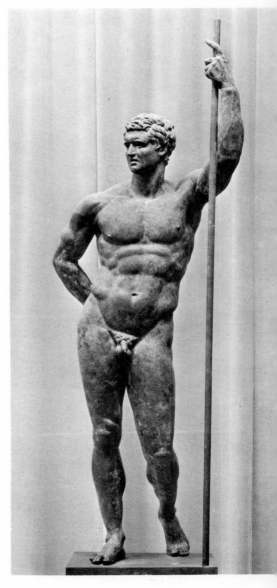

LEFT Seated boxer, bronze, *c* 250
RIGHT Portrait, perhaps of Demetrius I of Syria, bronze, *c* 250

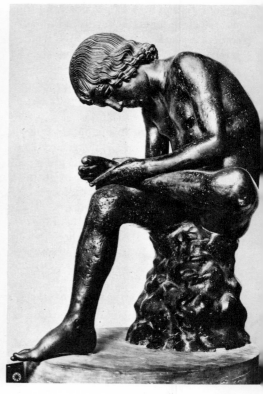

nursing her wine-jar, is almost a
caricature of the despair of the alcoholic
(ABOVE, LEFT). The wrinkled skin, the
scraggy breast and shoulder, the ropelike
tendons of the neck are treated almost
photographically in contrast with the
ideal simplicity of the drapery. The date
of the original is probably *c* 200. Equally
arresting, and very popular among
ancient copyists and adaptors, was a well
observed figure of a boy extracting a

LEFT Drunken old woman, after
an original of *c* 200
ABOVE Boy removing a thorn
from his foot, *pastiche* based on
an original of *c* 200

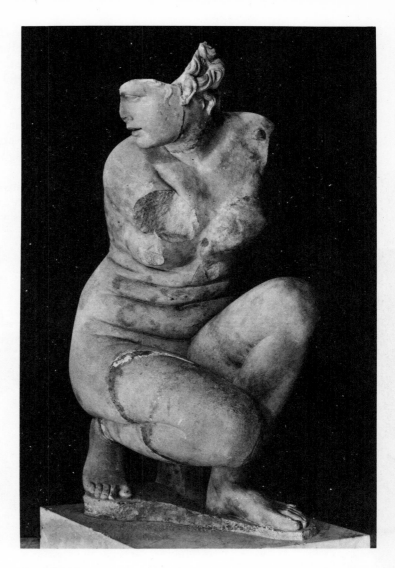

Crouching
Aphrodite, after
an original
probably by
Polycharmus of
Rhodes, *c* 200

thorn from his foot, the original
somewhat later than the drunken woman.
In one version (LEFT) a head of fifth-
century type has been substituted.

There is no obvious distinction
between mortals and deities in this
period: goddesses are portrayed as
women, beautiful but often less than
majestic. Aphrodite was a frequent
subject, usually in a variation or
development of Praxiteles' pose.

An exception is the new type of the
crouching Aphrodite, invented by one
Polycharmus, apparently a Rhodian
sculptor of the second century BC.
Essentially it is another genre subject, an
awkward pose from real life. It was
evidently popular, for it was frequently
copied (ABOVE). The goddess crouches
to wash herself, seated on her right heel
and balanced by the left foot set forward.
The legs point forward; but the head is

turned sharply to the right, carrying the upper part of the body in the same direction. The same goddess is represented in what is probably the most famous work of the period, the Aphrodite from the island of Melos ('Venus de Milo', OPPOSITE AND BELOW), by . . . andros of Antioch on the Maeander. The pose is an adaptation of a fourth-century portrayal of the goddess (the so-called Aphrodite of Capua) holding up the polished shield of her husband, the war-god Ares, to admire her own reflection in it: here, however, the right hand probably steadied the falling drapery, while the left rested on a pillar. There is powerful movement in the different direction of legs and arms, with the torso twisting between. The characteristics of beauty most admired in this period, c 200–100 BC, are clearly shown: small head, high waist, broad hips, full breasts.

Scenes of violence involving whole groups of figures were a feature of the period. Lysippus had shown the way,

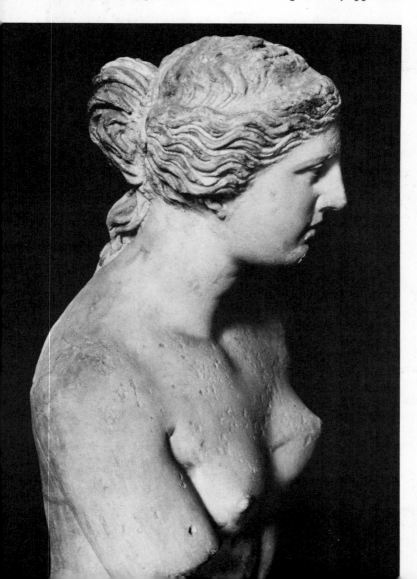

LEFT AND RIGHT
Aphrodite,
from Melos,
c 150

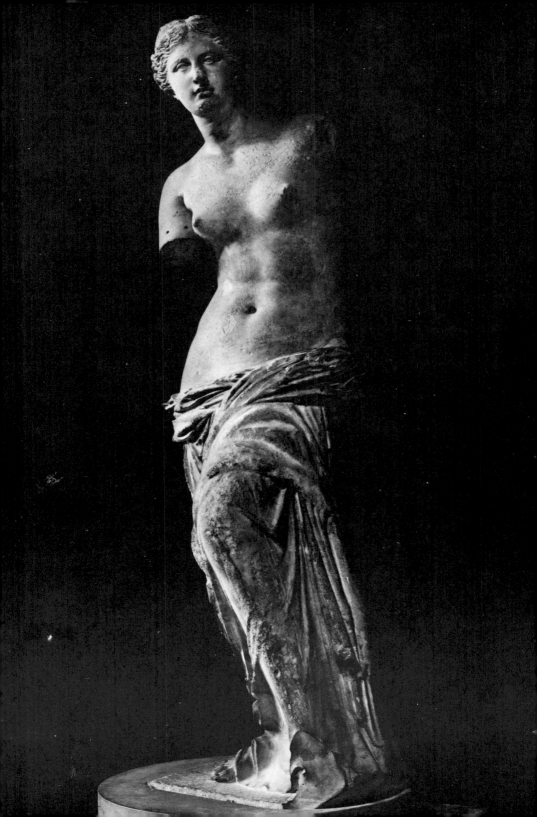

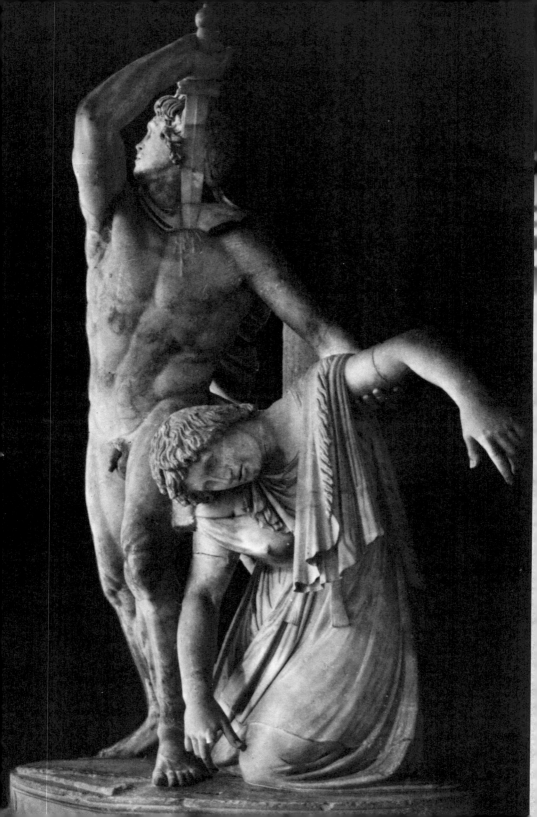

with his free-standing hunts and battles of Alexander, and his especial heirs were the school of artists centred on the kingdom of Pergamum in western Asia Minor. King Attalus I (241–197 BC) dedicated such a compositon in bronze to celebrate his victories over Gaulish invaders. Roman copies survive, over life-size, of a dying Gaul (BELOW), and a Gaul killing himself and his wife (OPPOSITE). The dying Gaul, his face lined with pain, sits in the attitude of one unable to rise: soon the right arm will give, and the body collapse lifeless. In the other group the dead wife hangs supported by her husband's strong left arm, while he himself turns away his head as he drives his short sword into his chest, and the blood gushes down.

Attalus dedicated a similar group in Athens, under life-size, and of these statues, too, copies have survived. His

LEFT Gaul killing his wife and himself, after a Pergamene original of 240–200

BELOW Dying Gaul, after a Pergamene original of 240–200

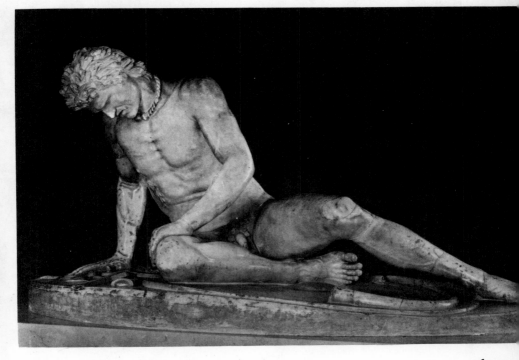

successor, Eumenes II (197–159), seems to have been responsible for building at Pergamum the Altar of Zeus and Athena, of which the sculpture is now in Berlin. The altar stood within a colonnade set upon a high base approached by a broad flight of steps between two projecting wings. There were two friezes, within and without. Little survives of the internal frieze, which told the story of Telephus, king of a city near Troy which Achilles destroyed. Of particular interest, however, is its episodic nature: Telephus himself is shown repeatedly in scene after scene, without any frame or other device to mark off one episode from the next. This repetition is an innovation in sculpture, though long known to Greek painters, and it was taken up by Roman narrative sculptors as a normal convention. The external frieze of the Altar of Zeus is of remarkable quality. We see the northern projection (OPPOSITE) and a part of the east frieze (BELOW). The composition still has the theatrical naturalism of the Pergamene school; but, as befits a religious purpose, the subject returns to mythology, to the war of the gods against the rebellious giants. Some of the giants are human in shape, others partly animal. They are being defeated and beaten down, but not without a struggle, and in their desperate lunging and writhing we are made aware how great the issue was for mankind as well as for the gods, the final victory of order over chaos.

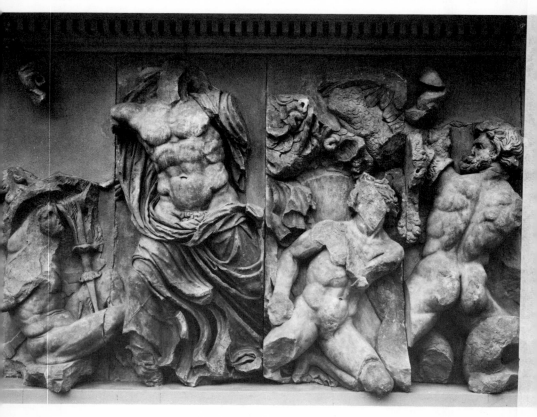

Altar of Zeus
and Athena
at Pergamum,
197–159:
RIGHT
North wing,
showing position
of main frieze
BELOW
East frieze,
battle of the
Gods and Giants

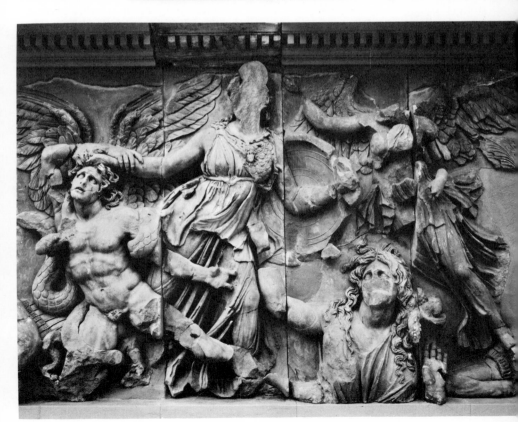

The most magnificent statue of the Hellenistic period is the Victory (Nike) from the northern Aegean island of Samothrace (OPPOSITE). She was probably an offering of the people of Rhodes, *c* 190 BC, to celebrate their victories over King Antiochus III of Syria. The goddess is in the act of alighting on the prow of a ship, her drapery streaming in the wind as the ship rushes through the waves, and her great wings beating to steady herself: at this moment there is equal tension in both legs and the feet are planted firmly. The right arm was raised, waving a victor's triumphal sash (not a trumpet, as in earlier restorations), and the head was turned to the left. The carving of the drapery, blown against the chest and stomach to an appearance of nudity and billowing out elsewhere, reminds us of the style of the later fifth century. But the enormous weight of the cloth, and the shapes of the folds, are quite different.

Nike (Victory) from Samothrace, *c* 200

Epilogue

The steady advance of Rome into the
Aegean world in the second century BC,
culminating in the sack of Corinth in 146
and the bequest of the kingdom of
Pergamum to Rome in 133, effectively
ended the independence of Greece. Her
new masters quickly developed a taste for
her art, and the copying industry was in
full swing by the time of Sulla's sack of
Athens in 87, since the Athena by
Cephisodotus or Euphranor (see p.
129) had already been copied before it
was buried then. Henceforth the ever-
expanding market for Old Masters
occupied most of the time and talents of
Greek artists, for originals were in
limited supply and immensely
expensive, and copies of them much
in demand.

New works of high quality and true
originality were few and far between.
Instead there was a vogue for *pastiche*. At
the lowest level, this could be a matter of
adding portrait heads of contemporaries
to copies of some famous divinity of the
classical period. At the highest, it gave
rise to such a masterpiece as the Laocoon
(p. 170). For this great baroque group of
the Trojan priest and his two sons, long
and rightly admired since its discovery in
Rome in the time of Michelangelo, is
not, as was thought, a Hellenistic work of
the second or first century BC but
Graeco-Roman of the first century AD,
when the elder Pliny saw it in the house
of the emperor Titus. This seems to
follow from the discovery in a grotto at

Blinding of Polyphemus by Odysseus,
by Hagesander of Rhodes
and others, *c* AD 25

Sperlonga, designed and decorated for the emperor Tiberius (AD 14–37), of a series of equally dramatic sculpted groups in the same apparently Pergamene manner, illustrating the resourcefulness of Odysseus, stylistically to be assigned to a single workshop and one of them signed by the same three Rhodians who carved the Laocoon. The Sperlonga groups are demonstrably pastiche, evidently commissioned for their setting, and echoing an unconventional version of Odysseus' story which is to be found in Tiberius' contemporary the poet Ovid. There is Odysseus with the dead body of Achilles, and attempting to steal the Trojan Palladium; Odysseus clinging to his ship in his encounter with Scylla, and the blinding of Polyphemus the Cyclops (provisional reconstruction pp. 168–9). The two latter compositions are colossal – Polyphemus is nineteen feet long – but the quality of these artists' work is still best judged from their Laocoon (OPPOSITE). The Trojan priest is punished for his disobedience to Apollo, who had forbidden him to marry or have children. Two serpents have emerged from the sea and are killing Laocoon and both his sons, seen here in front of an altar. The elder son, on the right, tries to step out of the serpent's coils; the younger is already dying of a bite in his right side. Their father struggles to tear away the encircling coils, but at this very moment he is bitten in the left hip. His chest arches, his stomach heaves at the pain, and we are to imagine a scream pouring from his open mouth. Father and younger son are Pergamene, and perhaps reflect a two-figure original; the elder son, recently added to the story by the poet Virgil, is in a different and classical manner. The group, like those from Sperlonga, was intended to be seen from the front only; for it is singularly ineffective from any other viewpoint.

The new dating of the Laocoon shows that not quite all originality was stifled under Rome. But *pastiche*, however impressive the result, is a limited kind of invention: the artistic heyday of Pagan Greece was over.

Laocoon, by Hagesander of Rhodes and others, AD 25–50

List of Illustrations and Acknowledgements

All works are of marble unless the material is named

109 RIGHT *Rome, Terme*
(Richter)

110–111 'Canon' (Doryphorus)
after a bronze original by
Polyclitus, 450–440 *Naples,
Museo Nazionale* (Mansell/
Anderson)

112 'Westmacott athlete', after a
bronze original by
Polyclitus, *c 450 London,
British Museum* (Trustees)

113 Diadumenus, after a bronze
original by Polyclitus,
440–430 *Athens, National
Museum* (Museum photo)

114–115 Amazons, after bronze
originals at Ephesus,
attributed to (left to right)
Polyclitus, Phidias & Cresilas
Rome, Capitoline (Richter);
Tivoli, Hadrian's Villa
(German Archaeological
Institute, Rome); *New
York, Metropolitan Museum
of Art* (Gift of John D.
Rockefeller, Jr, 1932)
(Trustees)

116 Caryatid porch of the
Erechtheum, 425–415
Athens, Acropolis (Courtauld
Institute)

117 LEFT Caryatids from the
Erechtheum *London, British
Museum* (Trustees);
RIGHT Procne and Itys, by
Alcamenes, *c 420 Athens,
Acropolis Museum* (German
Archaeological Institute,
Athens)

118 Nike (Victory) by Paeonius
of Mende, 425–420 *Olympia*
(German Archaeological
Institute, Athens)

119 *Akroterion* from Stoa of Zeus,
Athens, 420–410 *Athens,
Agora Museum* (Museum
photo)

120 and 121 LEFT Frieze on
parapet surrounding temple
of Nike, Athens, *c 410*:
figures of Victory with bull
for sacrifice; Victory untying
her sandal *Athens, Acropolis
Museum* (Alison Frantz)

121 RIGHT Nereid (sea-nymph)
from tomb monument at
Xanthus, *c 400 London,
British Museum* (Trustees)

122–123 Frieze inside temple of
Apollo, Phigalia (Bassae),
c 420: LEFT Lapiths and
Centaurs: BELOW Greeks
and Amazons *London,
British Museum* (Trustees)

124 *Akroterion* from temple of
Asclepius, Epidaurus,
400–375 *Athens, National
Museum* (Museum photo)

125 Gravestone of Hegeso, Attic,
*c 400 Athens, National

126 Gravestone of Dexileos,
Attic, 394 *Athens, Kerameikos
Museum* (German
Archaeological Institute,
Athens)

128 Eirene and Plutus, after a
bronze original by
Cephisodotus, 375–370
Munich, Glyptothek
(Museum photo)

129 LEFT Apollo Patrous by
Euphranor, *c 370 Athens,
Agora Museum* (Museum
photo); RIGHT Bronze
Athena attributed to
Euphranor, *c 370 Athens,
National Museum* (Museum
photo)

131 Hermes and the infant
Dionysus, by Praxiteles,
c 350 Olympia (German
Archaeological Institute,
Athens)

132 Aphrodite of Cnidus, after
an original by Praxiteles,
c 340 Vatican

133 'Aphrodite of Arles', after
an original attributed to
Praxiteles, *c 340 Paris,
Louvre*

134 ABOVE Head of Aphrodite,
attributed to Praxiteles,
c 350 Petworth, Sussex
(Mansell Coll.);
BELOW LEFT Head from
Chios, *c 350 Boston, Museum
of Fine Arts* (Trustees);
BELOW RIGHT Head from
Tegea, *c 350 Athens,
National Museum* (Museum
photo)

135 Apollo killing the lizard,
after an original by Praxiteles
c 340 Vatican (Museum
photo)

136–137 Base for a statue by
Praxiteles, from Mantinea,
c 350: front, the contest of
Apollo and Marsyas; sides,
three Muses on each face
Athens, National Museum
(Hannibal; German
Archaeological Institute,
Athens)

138 Bronze boy, found off
Marathon, 340–300 *Athens,
National Museum* (Hirmer)

139 Heads of Heracles (left) and
a warrior from pedimental
sculpture of the temple of
Athena Alea at Tegea,
*c 370–350 Athens, National
Museum* (German
Archaeological Institute,
Athens)

140 LEFT Base of column of
temple of Artemis at
Ephesus, 350–330 *London,
British Museum* (Trustees);

RIGHT Gravestone from the
Ilissus, Athens, *c 340 Athens,
National Museum* (Museum
photo)

141 Bronze athlete, found off
Antikythera, *c 340 Athens,
National Museum* (Hirmer)

142–145 Sculpture from the
Mausoleum at Halicarnassus,
c 350 London, British Museum
(Trustees)

142–143 Frieze from
podium, battle of Greeks and
Amazons
144 Frieze from *cella*,
charioteer
145 Figures of Carian rulers
('Mausolus and Artemisia')

146 LEFT Alexander the Great,
attributed to Leochares,
*c 330 Athens, Acropolis
Museum* (Hannibal)

146 RIGHT and 147 Demeter
from Cnidus, attributed to
Leochares, *c 330 London,
British Museum* (Trustees)

148 Apoxyomenus, after an
original by Lysippus,
325–300 *Vatican* (Museum
photo)

149 LEFT Bronze athlete,
attributed to Lysippus,
*c 325 Malibu, J. Paul Getty
Museum* (Museum photo);
RIGHT Agias, original of
344–334, perhaps after
Lysippus *Delphi* (Alison
Frantz)

150 ABOVE Alexander the
Great, after an original
attributed to Lysippus, *c 330
London, British Museum*
(Mansell Coll.)

150 BELOW and 151 Alexander
hunting, sarcophagus from
Sidon, 325–300 *Istanbul,
Archaeological Museum*
(Mansell/Alinari)

152 Athlete scraping himself,
bronze, from Ephesus, *c 300
Vienna, Kunsthistorisches
Museum* (Museum photo)

153 Goddess, found off Cnidus,
bronze, *c 300 Izmir,
Archaeological Museum*
(University of Pennsylvania
Museum)

154 LEFT Demosthenes, after a
bronze original by
Polyeuctus, 280–279 *Oxford,
Ashmolean Museum* (Visitors);
RIGHT Bronze head, found
off Antikythera, 250–200
Athens, National Museum
(Museum photo)

155 Head of a Berber, bronze,
from Cyrene, *c 250 London,
British Museum* (Trustees)

156 Seated boxer, bronze, *c 250
Rome, Terme* (Hirmer)

Index